HOW TO ENJOY
ART

A Guide for Everyone

BEN STREET

YALE UNIVERSITY PRESS
New Haven and London

First published by Yale University Press 2021

302 Temple Street, P. O. Box 209040, New Haven CT 06520–9040

47 Bedford Square, London WC1B 3DP

yalebooks.com | yalebooks.co.uk

ISBN 978–0–300–25762–5 HB

Library of Congress Control Number: 2020952109

10 9 8 7 6 5 4 3 2 1

2025 2024 2023 2022 2021

Cover designed by Alex Robbins

Text designed and typeset by Tetragon, London

Printed and bound in China

Front cover: Helen Frankenthaler, *Orange Mood*, 1966. Acrylic on canvas, 213.4 × 201.9 cm. Whitney Museum of American Art, New York. Artwork © 2021 Helen Frankenthaler Foundation, Inc./DACS, London. Digital image © 2021 Whitney Museum of American Art, New York/Licensed by Scala.

CONTENTS

INTRODUCTION

T HIS is a book about the value of art. Not its historical, economic or even artistic value – plenty of books already exist on those subjects. It deals instead with the kinds of pleasures art can provide, and how we can access those pleasures through certain acts of attention. It's a matter of making better use of what we already bring to our encounters with art, and allowing ourselves the time to do so.

Not all works of art are made for absolutely *everyone* to enjoy, of course. There is no painting, sculpture or installation that might appeal equally to every living person, just as no book, song, film, poem, performance or TV programme would. And there are certainly artworks that are hard to enjoy, or whose intention is not to provide pleasure; they may, rather, engross, engage, challenge or enlighten us. But regardless of the *sorts* of experiences art can provide, one thing can be said: works of art, like all the arts, ought to be for *anyone*. It ought to be possible for anyone, no matter who they are, to be able to have an enjoyable and memorable experience with art; to encounter any work of art ever made and find some point of contact between that object and their own lives. And it *is* possible; after all, that's what works of art are for. But saying that it *ought* to be is a tacit acknowledgement that it often isn't. We'll get nowhere unless we admit that, and think through the reasons why it might be the case. In order to do what they're supposed to, works of art need viewers, just as books need readers, and music needs listeners. But the fact is that there are blockades between any given work of art, silently sitting on its pedestal in a gallery space,

and many of its potential audience members. Although these aren't literal blockades, they might as well be. Financial constraints, lack of time, physical inaccessibility, lack of awareness, sheer absence of interest, and many other complex reasons all act like literal impediments to accessing real works of art, like sandbags piled up at the museum door and heaped around the objects. To many potential visitors, museums and galleries are, despite their size, as invisible as government buildings. They're what you pass by on your way to somewhere else.

There are other invisible blockades, too. One pervasive one is about what you need to know before you can even *have* the art experience. The idea that specialist historical knowledge is required to gain access to the meanings of works of art generates an unnecessary distance between an object and its potential viewer. You might think of that expertise as a sheet of glass through which the work of art has to be viewed, as though the object literally can only be seen through a particular set of known data: dates, names, periods. But this data actually doesn't need to be translated into a metaphor: it's everywhere you look. Museums often cover their interior walls in explanatory text, which you encounter long before you get to see an actual work of art. Because that explanation is generally applied directly onto the wall using rub-on lettering, it becomes somehow part of the building's structure itself, as though the whole institution is built of language, which encircles, protects and maroons the art objects inside. Smaller galleries do something subtler, providing printed-out press releases that often make use of academic jargon that shuts out most readers. Wherever we encounter it, art comes wrapped in words. We experience works of art – in museums or galleries, sacred sites or websites, or on screens in our homes – nested in language, which explains, contextualises and analyses the work for us. This may in part account for a phrase that is commonly used to describe how we come to engage with and interpret works of art: we *read* them.

If we're really honest, though, we know that written and spoken language often falls short in the face of art. We only have to think of other art forms to prove that's the case. Consider, for instance, music. A music historian might be able to tell you the name and biography of every musician that played on a particular recording, the specific kinds of instruments played, the particular technology that recorded the song, even the dimensions and cost per hour of the recording studio, but there is nothing in that historian's body of knowledge that can account for the way that song affects *you*, the listener. A similar thing might be said for a poem, which a specialist could break down in terms of its complex inner structure and allusions to other poetry, or its place within the writer's life, or its significance in terms of literary history, or any number of possible interpretations – but that specialist could never really explain how that poem might resonate with *you*, or how it might lodge within your memory for years. Even music and literary historians would, I imagine, concede this shortcoming in their scholarly work. There are aspects of culture – pretty fundamental aspects, you might think – that academic analysis is not capable of describing.

Art history is no different. No amount of academic knowledge of an artist's practice, the context of a work's manufacture, the iconography of a particular scene, or a sense of its place within a sweeping narrative of art history can account for how works of art can reach across time and speak to us directly. This is an experience many of us have had, the very one any of us ought to be able to have. But the distinction between these academic approaches is that, unlike music history or literary history, art history is highly visible. I can listen to a song I like any time I wish, without any of that detailed knowledge getting in the way, or me being even remotely aware of it. The same goes for a poem, which I can encounter on the page or spoken aloud without knowing a thing about who wrote it, or when, or why. But art history is different. Art history is always *attached* to objects. It's present *around* the work of art,

be that in the form of text on a label, a voice on an audio guide, or in the actual shape of the museum itself, teeming from top to bottom with other objects that are like, or instructively *not* like, this one. It's invisibly present, too, in the kinds of works of art we get to see, and how we see them. It's because works of art, unlike songs or poems, are actual, material *things* that they come to us within physical contexts that frame and shape our understanding of them. All of this considered, it's no wonder that many visitors to museums feel they lack the ability or skills to be able to make sense of the works of art they see. It's no wonder that many people will respond instinctually to a song they hear on the radio but might not feel confident to do the same with a painting. Yet, in a fundamental way, those two things are really not very different.

It's not that art history is a pernicious influence, like an evil fog that hangs around the pictures we see. Art history, like music history or literary history, is an essential part of how we're even aware of the existence of certain forms of culture. It has determined the preservation and display of thousands of objects all over the world. Like history, art history is a story told in the present about events in the past; it's not the past itself. It's the method we use to assess, interpret and make sense of global visual culture, and since humans have, for as far back as we know, expressed themselves in visual terms, it's a central part of how we understand who we are. The currents of art history have determined what we get to see on the walls of museums and galleries, what we read in the pages of art books, see on TV, even, to some extent, how much money someone's willing to pay for an object in an auction. Art history has also determined the choice of objects in this book, since they are all visible in institutions across the world, and the decision to make them visible has come, in part, from art history. But art history isn't a consistent or singular thing; like art itself, it's a continually fluctuating and shifting practice. One of the things this book intends to do is to hold art history itself up to the light, to make it visible not as a set of facts

but as a body of interpretations made by other human beings just like us. To do this, this book makes an attempt to step away from art history for a while, by acknowledging that it can't say *everything* about our experiences with art. It's an attempt to suggest ways in which we might approach those experiences *without* falling back on the existing language of art history. The point of this is twofold: to freshen our engagement with art by emphasising the present-tense experience of actually looking at it, and to explore ways in which anyone might find value and enjoyment in spending time with works of art, wherever and whoever they might be.

Ideas about art can seem rather systematic, as though their writer was able to respond in a cool and orderly way to the work itself. That's the problem with writing about art: it can't hope to capture the rush of unsorted emotional, sensual and intellectual experience that constitutes looking at objects in a specific place. Words can seem to be the only medium we have to translate that experience, yet they often seem to sell it short. If we acknowledge this shortcoming, we can start to unpick art history itself, and allow for a greater diversity of interpretation to take place. Works of art *themselves* are actually a useful guide to this, as they are always made within the knowledge of their medium, and in terms of their medium. If we take that idea seriously, we might see the interior of a great art gallery as a buzzing, clanking factory of interpretation, with artworks the embodiments of speculation about what art actually is. This is not to suggest a dry, self-referential approach with works of art only ever talking about art; instead, it's a suggestion that, long before art history turned up, works of art were *already* interpreting other works of art. If we're sensitive to the ways they do that, we might see the field of possibilities opening up. Art can be our guide to thinking about art.

Some artworks are so famous, so widely reproduced, so extensively written about, that the experience of actually seeing them can be an unsettling one. Diego Velázquez's huge painting known as

Las Meninas ('The Maids'), made around 1656, is by far the most famous painting in the museum in which it hangs, the Museo del Prado in Madrid. In fact, it's been called, on many occasions – and not a little dauntingly – the greatest painting ever made. It seems as if, to paraphrase the writer Mary McCarthy talking about the city of Venice, everything that could possibly be said about it has already been said, including this statement. There are innumerable books, theses, essays, lectures and programmes on the painting, with more emerging all the time. Each new analysis is built on top of the previous ones, tweaking what's already been said by refining our knowledge of all the details of the painting's content: from the name and personal history of every depicted character, to the geographical source of every piece of painted fabric and crockery, and the cost in 1656 of every stroke of paint on its surface. Just knowing that this mountain of interpretation exists can make seeing the real thing a little discombobulating. How can I even *begin* to think about this painting, given the ghosts of all these explainers that hover around it? What could be said that hasn't already been said?

The fact is that no work of art, however famous and however much has been written about it, is closed off to further discussion. There is no point at which everything that could be said about it has been said, as Mary McCarthy, who after all found plenty to say about Venice, might admit. The exhaustive art-historical dissections of the painting certainly provide all sorts of new frameworks for thinking about this very famous work of art. But there are many things they *can't* say. They can't account for the strangeness of this object: its mysteriousness, its haunted atmosphere, its curiously physical yet ethereal surface. They can't explain what it does to you as you stand or sit in front of it: how it speaks to you or doesn't, or how it moves you, whether to tears or indifference. You might find yourself, as I have, facing the real object in the museum, and finding that all that explanation feels superfluous to the experience of looking at the actual painting, just as those details of the recording studio and the

instruments feel incidental to the experience of listening to a song. If you feel that everything's been said already, maybe *saying* is the problem. Maybe one way we might open up points of contact with a famous work of art like *Las Meninas* is to start thinking about other things that happen when we're there in front of it. Not just *reading* the content of the painting and translating that into language, but paying closer attention to other aspects of experiencing the work that perhaps aren't so easily analysed in art-historical terminology. This means paying attention to things that might actually appear quite obvious, things we might not otherwise consider: the scale of the work in relation to our own bodies; the way it was made and the marks of its making; the expression and effect of its colour; the way it feels to be there in its presence. These acts of attention might not need to be expressed in words, or even expressed at all. But for the purposes of this book, they are experiences that will form the basis of how we can come to find our own way to the works of art we see. By talking about them, I hope to make a case for their importance. Thinking about these aspects of works of art allows us to find our own ways to engage with artworks, making use of what we all naturally bring with us – above all, our bodies, our imaginations and our memories – to provide fresh channels of interpretation, to find points of contact and routes to enjoyment.

What's implied here, of course, is the need to see works of art in person. That's not to overlook or downplay the importance of reproductions of artworks. There's no doubt that some of the experiences alluded to above might happen with a copy of an original on the internet, in the pages of a book or even on a postcard. But some of the more central ones can't. Finding new and independent imaginative routes into art is best done in front of the real thing. It doesn't mean seeking out the specific works of art chosen for this book, or even very well-known ones. It simply means seeking out the real object whenever you're able to, and making the most of the experience of sharing physical space with it. This isn't always easily

done. Above and beyond the logistics of getting to a museum or gallery and carving out the time you need to get the best possible experience there, there's the force of habit that many of us bring with us into the art space: the desire to see everything, to read everything, to cover every room. Even in a reduced context – a commercial gallery, an artist's studio, a small-scale exhibition, on the street – this tendency remains. Stopping and staying with the work of art is the only way to do it. Keeping control of these natural habits and finding some way to slow down and give works of art the time they need is central to how we might improve our experience of art – and even start to enjoy it.

This book is by no means a definitive guide. No art book is. The works of art chosen are from a wide range of geographical, historical and artistic contexts, but naturally they can't be comprehensive. There are many omissions, in particular of works of art that don't lend themselves to being reproduced very effectively. That's not to say that what's said in this book, about ways we might approach the art experience and get more from it, can't be applied to these other forms of art that aren't specifically covered here. Sound art, for one, is obviously pretty well impossible to discuss in a book. Likewise performance and video, which by their nature unfold over time, sometimes a very long time, can't really be described without an exhaustive account of everything that happens over the course of their duration. This might account for why these forms of artistic expression, which are vital to the story of twentieth- and twenty-first-century art, are often left out of written accounts of that period, or get sidelined in favour of more easily reproducible and collectible art, like paintings and sculptures. The fact is that some forms of art are better suited to being written about, which means they occupy a place in history that might well have been given to artworks that aren't. Having said that, the thematic categories into which this book is separated can apply to a much wider range of art than the choice of objects might suggest. It's certainly the case that

video makers think about colour and scale, and that performance artists consider placement and process when they develop their work. So, while not encyclopaedic in its scope, this book is, I hope, flexible enough in its ideas that it might find a useful application wherever art itself is found.

Colour

Speaking in colour

ART can be frustrating. The age-old question *What does this mean?* is almost never met with a straight answer, no matter who you ask. The reason for this is that it's generally not an answerable question. The same goes for music, film, fashion, architecture – practically anything worth thinking about. It's not that works of art don't mean *anything*, or conversely that they could mean anything you want them to mean – it's that 'meaning something' isn't the whole of what a work of art does. They operate at many different levels, and 'meaning' is only one of them. Take the example of a pop song: it might be *about* a particular subject (love, let's say) but the way that subject is conveyed to a listener, through certain combinations of sounds, made and recorded in a particular way, can generate all kinds of other, even contradictory responses in the listener (hate, let's say). So the question *What does this mean?*, rather than being answered with a set of historical or biographical data put forward to 'explain' the work of art, might be better addressed by thinking about what we actually see when we face the object in question, namely scale, material, placement, and, perhaps most immediately, colour. With that in mind, we might usefully tweak the question to *How does this mean?*

Colour is one of the first ways we make sense of our place in the world. Once we, as babies, have developed the capacity to see

colour, we immediately put that knowledge to use, using colour as a tool to distinguish between objects in our visual field. Words ('cat', 'ball', 'door') eventually get attached to these coloured shapes, but firstly they are simply visual phenomena that help us locate ourselves in relation to the world around us, like points on a map. That means that we all have a sense memory, however deeply buried, of responding viscerally or instinctively to colour, of moving towards or away from these vaguely defined coloured forms. This kind of deep knowledge underpins the whole cultural universe we inhabit, from warning signs to fashion, from product design to works of art. Colour's ability to speak to us directly – the way a warning sign articulates its message in the split-second instant *before* we actually read it – seems to be a basic truth of how we navigate the world around us. In recognising this, we can open ourselves up to the potential of works of art to speak to us in an immediate way through colour alone – as it were, before we've even learned the words to say what it is we're actually seeing.

The colour of a work of art is central to the way in which it draws us in. It's often what many of us respond to most deeply in an artwork we see for the first time. And the colour of a work of art – something we might, in a scholarly mood, not take all that seriously – has a profound effect on the life of that object. A colour's desirability will broaden an artwork's pool of potential buyers, often driving its price up. Red paintings, they say, sell better than those in other colours, which in turn affects an object's visibility, both in reproduction and in written accounts. Something as seemingly arbitrary and capricious as the attractiveness of an artwork's colour can absolutely affect its resonance in the history of art. It's a struggle to find words to explain the mysterious appeal of colour, central though it is to what we see on the walls of museums and galleries. Describing the experience of being swept away or overwhelmed or simply charmed by colour – common enough experiences in art museums to keep the trade in postcards nice and brisk – might

seem doomed to fail. So we're faced with a kind of fissure, which separates the deep-rooted emotive appeal of colour and the language we use to talk about art.

All art is, to a greater or lesser extent, coloured. Even black and white photography, or all-white or all-black paintings can be richly colourful, if a viewer is prepared to really look closely. One claim can at least be made as regards art and colour: some colour is applied (say, paint on a wall) and some is already there (the natural colour of marble, for instance). This means that all art speaks in colour. It's not quite true to say that colour is a 'universal language', as is sometimes said, given the enormous diversity of cultural associations of a given colour depending on where and when and even who you are. But it *is* reasonable to claim that colour is one of art's distinctive modes of communication. As with its scale, a work of art's colour speaks first, before content and context come into play. It's often one of the ways that works of art remain present in the remembering mind, even though the colour of an artwork is often not quite the same as you remember when you see it again. This is one of the pleasures of revisiting works of art: they change as you do.

Here's an example of how colour might speak beyond what the work of art is apparently telling us in terms of its literal content (Fig. 1). It's a section of painted wall from a villa in Pompeii, Italy, known by modern historians as the Villa of the Mysteries. The villa got its name from the famous sequence of wall paintings in one of its rooms, whose content and meaning has remained inscrutable, despite countless theories posited by generations of scholars and visitors. Many of these theories are preoccupied with interpreting the narrative content of the paintings, which means identifying specific characters or putting a figure's curious gesture or pose into words. Attempts to 'solve' works of art like this one are commonplace both in academic art history and its appearances in popular culture. You might think of Dan Brown's 2003 book *The Da Vinci Code*, which dramatises attempts to crack the hidden meanings of

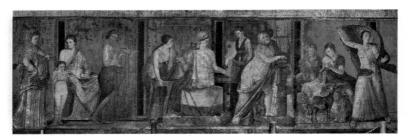

FIG. 1 Fresco from the Villa of the Mysteries (detail), Pompeii, c.70–60 BCE

famous paintings. Artworks are treated in this way like crime scenes: given enough scrutiny and expertise, their secrets will suddenly be revealed; they will become obsolete, and we can move on to the next one.

But treating artworks as problems awaiting a solution means overlooking many of their essential features. Their physicality, for one, by which we mean their scale, their surface and how they were made. Their placement, for another: how they exist in and respond to a particular actual space. And finally, and perhaps most importantly, their flexibility: the fact that works of art don't or can't possess a single meaning that remains fixed for all time. Each passing year changes the potential meanings of artworks, since the meanings of works of art are generated by being looked at, and audiences, naturally, change. There is no knowing what the original inhabitants of the villa thought about these mysterious paintings. And if an ancient Roman guidebook were suddenly to be unearthed onsite, this would not give us the final word on what the paintings *mean*, but what they might have meant at a particular point in history to a particular person. What makes them art is that they have the capacity to welcome and withstand any number of possible responses. By nature, their meanings are slippery, resisting closure.

The Latvian-born American abstract painter Mark Rothko understood this. Visiting Pompeii in the late 1950s, he saw the

Villa of the Mysteries frescoes as having the same kind of spirit as his own paintings. Anyone familiar with Rothko's work will have no difficulty seeing the villa through the modern artist's eyes: clearly it was the expanses of rich red *behind* the figures that Rothko found so captivating, given their resonance with his own work. What's interesting here is that Rothko's response is very much *not* about art-historical decoding. Instead, he recognises within these ancient images, made in a wildly different context to his own, a certain kind of expressive kinship. Rothko's paintings, with their slabs of deep reds, blacks, greens and browns, attempt to conjure up certain emotional and spiritual states, which would, he hoped, resonate with a receptive viewer. Interestingly, Rothko also asserted the physicality of his own work, demanding his paintings be shown without frames or glass and hung low to the ground. He even encouraged viewers to stand about eighteen inches from their surfaces in order to properly experience them. It's worth trying that with other paintings, even non-abstract ones, if they're large enough. At that distance, the edges of paintings recede into your peripheral vision, as do wall labels, other works of art and other people. What becomes evident is not the content of paintings, their narratives or subjects, but their specific presence as objects. It's a little like standing face to face with another person at close range: after the initial awkwardness has passed, a more acute sense of them as a physical being emerges.

Standing that close to a Rothko, security alarms notwithstanding, means that you are engulfed by, swamped by, his huge fields of rich colour. This might or might not have the desired effect. Many people are put off by this sort of grandiosity. Being put off by Rothko was, in fact, a starting point for many innovative ideas in modern art. But, regardless of one's response, it remains of use in our thinking about colour in art, because Rothko evidently recognised that colour alone, without it needing to be translated into language or used to describe the visual world, might be able to speak to a spectator directly, in an immediate way, that cuts across

levels of expertise, prior knowledge or experience. The hundreds of people who visit rooms of Rothko paintings in museums across the world and remain there, transfixed, moved, or overwhelmed, are testament enough to the artist's understanding of how colour speaks. The fact that he found the same kind of effect in the ancient wall paintings of Pompeii might seem ahistorical – those frescoes aren't abstract, after all, at least not in a conventional sense – but might also be seen as a profound moment of awareness: that the use of colour as an expressive effect is something that might be a core component of art whenever or wherever it might be made. It might even be part of the very definition of art itself.

The power of colour

Museums often have a hard time convincing modern audiences to get excited about works of art like the one in Fig. 2. The traditions of western European art are deeply rooted in representations of Christian narratives, to the extent that followers of other religions, or of none at all, might think themselves excluded by an object like this one. But it's worth remembering that religious objects encountered in museums are always separated from the original setting that provided a context for their spiritual dimension. That separation generates a new set of thoughts about the object that almost certainly weren't in the head of the artist who made it. Ideas about niceties of technique, or a more general historical context, or the quality of this painting compared to that one (all central ideas in museum displays, however subtly expressed) were almost certainly not under consideration when this work was put together in a studio in Brussels, Belgium, over 500 years ago, by the artist Rogier van der Weyden and his crew of assistants. What Rogier and his team were doing was fulfilling a brief from a client, getting a job done: decisions made in the studio, about content, colour and detail all related to

FIG. 2 Rogier van der Weyden, *The Crucifixion, with the Virgin and Saint John the Evangelist Mourning*, *c*.1460. Oil on panel, left panel 180.3 × 92.2 cm, right panel 180.3 × 92.5 cm. Philadelphia Museum of Art

that task. At least, that's what we usually assume. But in fact we don't know to what extent Rogier deviated from the specifications, because, as is so often the case in works of art of the distant past, the contract no longer exists. Even if it did, like the Roman guidebook, it would have to be treated with a measure of scepticism, and not as a key to unlock the painting's meaning. To what extent, for instance, the unknown client insisted on, say, the presence of details such as the skull's missing front tooth, or the subtle vein standing on the neck of the man on the left, is not known to us. It seems unlikely anyone would be that specific. This sort of thinking might seem

nit-picky, or absurd, or not really relevant, if your focus is on the strict triangulation of artist, patron and object. But perhaps there might be more to say. Perhaps a painting like this is not so easily explained away. It's a useful thought when encountering a work like this, because it's details like these – seemingly irrelevant elements that appear to have been added because the artist wanted to, for whatever reason – that allows them to speak beyond the narrow confines of the contract. These seeming irrelevancies are ways into the painting for all of us, whoever we are and whenever we're seeing it. They are points of contact between the painting's time and our own: sparks that leap across the gulf of history.

A simple memory exercise is a useful method of thinking through the idea of how art speaks in colour. What resonates when you turn your back on this painting, or close your eyes? What seems to remain in the mind of many viewers is, perhaps unsurprisingly, the pair of bright red drapes that hang behind the figures in both parts of the painting. They seem to remain, like after-images of bright light, inside your mind. The traditional historical explanation for these relates very closely to the narrative content. Since they're hung in this case behind religious figures – the crucified Jesus Christ and his weeping mother Mary – the consensus has become that they are cloths of honour, such as were conventionally hung, in Christian cultures, behind thrones. This interpretation casts the cloths as framing devices that are there for one simple reason: to underscore the theological elements of the painting, like a highlighter on a piece of text. In this way of thinking, their colour can be interpreted in a range of ways – as religious symbolism (red for spilled blood, say), as an economic indicator (which would involve tabulating the cost of red pigment), even perhaps as some clue to the identity of the patron (a colour in the family crest, perhaps). But it's also reasonable to suggest that the red of the cloths needn't be 'read' at all: the colour is experienced viscerally, physically felt, through a surge of optical force that sits beyond an easy explanation. It's not a stretch

to imagine Mark Rothko nodding approvingly at the tremendous energy of those planes of pure colour. While the figures themselves enact theatrical poses of despair and suffering, that red seems to be doing something different, speaking in an alternate, maybe even jarring tone that pulls the painting in a different direction. It's the intensity of that colour that generates a resistance to the closure that is sometimes sought when looking at works of art. It keeps the painting open for our own responses. And this openness to possibility is what ultimately makes looking at art worth your time.

So far, we have been speaking about colour as something able to speak in a different register to the narrative content of works of art. Let's call this colour's 'tone of voice'. A little like the key of a piece of music, choices of colour in a work of art create a certain atmosphere before we even start to interpret it as depicting something. The Italian Renaissance painter Raphael, for instance, is a master of generating atmosphere through colour before the literal content of his works is fully understood. The tone of voice of a Raphael painting is often a tranquil and serene one, which is evoked first through subtly balanced relationships between colours. This tone is something born of a combination of cultural expectation, visual intelligence, economic energies and theological convention, among other things, not that any of them neatly explain why his paintings feel the way they do. It's certainly the case that Raphael's use of colour is part of his expression of his subject matter. But it's equally true that someone not of Christian background could find themselves held entranced by one of the artist's depictions of a Christian subject, just as anyone might be spellbound by a religious song, or awestruck by a religious building, regardless of their belief in its meaning.

Purely abstract works of art, such as a 1966 painting by the American artist Helen Frankenthaler (Fig. 3), might be thought of as having avoided this problem by doing away with subject matter altogether. The artist could be said to have reduced the

FIG. 3 Helen Frankenthaler, *Orange Mood*, 1966. Acrylic on canvas, 213.4 × 201.9 cm. Whitney Museum of American Art, New York

language of art down to pure mood by completely abandoning any reference to the visual world. This painting is even *called* 'Orange Mood', as though to stake its claim as a straightforward generator of atmosphere. Our experience of this painting must come out of an engagement with the facts of the case, first and foremost: the painting's scale, shape, colour, texture, tonality and fabrication. As an abstract artist, Frankenthaler's primary expressive territory was in the paint itself and how it was made to behave. Unlike the Rogier van der Weyden painting, we can't obviously build a narrative as a

'second layer' on top of our experience of the artist's use of colour. What you see is what you get. Or rather, what you see is what you see; what you *get* is what you do with what you see.

A useful truism: the simpler a work of art looks, the more there is to see. It's often the case with very expensive cuisine, to make a hopefully useful analogy, that the dish on the plate looks fairly simple; the value comes in the choice and combination of very specific – and often very expensive – ingredients as well as the skill and fame of the chef and the exclusivity of the restaurant itself. And as with dining in an expensive restaurant, looking at a work of art like Frankenthaler's seems to demand absolute attention to every part of the experience. To do that, it helps to try and be very precise about the nature of the painting, as though you only had a limited amount of time to memorise its qualities. Describing it to someone who can't see it is a helpful way of honing this. What qualities of this painting might be discussed in a context like that? Colours sit on top of other colours so that they are visible *through* them – the paint has been laid down like veils. In fact, the artist poured very thinned acrylic paint onto a canvas laid onto the ground, without using a brush, and you can see that if you really look. Where each colour meets, there's sometimes a fuzziness, like an ink blot or stain. Some colours leave drips and dribbles: the artist was quite clearly happy for her process to be immediately apparent to the viewer. And the colours themselves are clearly chosen to vibrate against each other: orange and blue are complementary colours, meaning that they generate an optical buzz when placed side by side. The orange of the painting is only that intense *because* of the action of the blue, so the 'Orange Mood' of the title is partly conjured up by the non-orange parts of the picture. The painting is an assemblage of all kinds of colour resonances, some punchy and potent, others soft and discreet. Some seem to have happened through the accident of the paint's spread and soak, others are evidently carefully arranged. And so on.

What's revealing in this investment of attention – which could continue for much, much longer – is the nature of the artist's choices. A really attentive viewer, alive to the physical reality of the art object, can begin to imagine the process of the object's being made, can even picture themselves standing beside the artist as the paint was poured.

This kind of attention to the act of making is especially rich when looking at two-dimensional artworks, particularly paintings. This may be because most people have some memory of using paint as a child, whereas the majority of us didn't spend our formative years in a bronze foundry or video-editing suite. In any case, staying with the artwork, investing one's attention in it, is part of the process of a deep engagement with an artist's intelligence. That way, the painting as the product of a negotiation between a body (the artist's), a place (the studio) and matter (paint, surface and tool) might become as central as it needs to be for our engagement with works of art to really resonate. Any of the artworks in this book can be imagined in this way. It's a helpful way of reminding oneself that decisions about how a work of art will look are often made in the making – and therefore we really ought to pay more attention to the physicality of works of art, rather than leaping to read them like words on a page.

Certain techniques in artistic practice can remind us of the fiction of art, which is an obvious truth that isn't always taken into account. The Rogier van der Weyden painting discussed earlier is first and foremost a constructed fiction, made largely of organic matter, in which certain arrangements of colour and light evoke the visual appearance of, in this case, the crucified Christ, his mother and Saint John the Evangelist. As dreary as that sentence sounded, it's meant to be a corrective to a standard reading of a work like that, which might well begin: 'this painting depicts'. *Depicting*, or picturing, is where some of the intelligence of visual art resides. But the traditional focus on *what* the painting depicts rather than

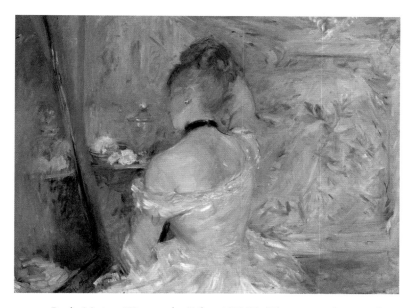

FIG. 4 Berthe Morisot, *Woman at her Toilette*, 1875/80. Oil on canvas, 60.3 × 80.4 cm. Art Institute of Chicago

how (or, eventually, and more cautiously, *why*) means that artworks become not much better than reproductions of themselves. Very famous and much-reproduced works of art often get reduced to a verbal shorthand of their subjects in this way: the sunflowers, the mysteriously smiling woman, the melting clocks. Some works of art, though, foreground the act of making, and so nudge us towards considering the *how*. Helen Frankenthaler's abstract painting clearly does that, but even artworks whose subject matter is apparent, like the painting by Berthe Morisot entitled *Woman at her Toilette* (Fig. 4), lays out the basic truth in its flickering brushstrokes. This is a painting, first and foremost. The visibility of the marks of the brush are – among other things – a means of calling attention to the artifice of the endeavour, like an actor breaking the fourth wall in theatre, or an author turning up as a character in their own book. It is self-consciously made, not to burst the bubble of our belief,

but rather to inflate it still further: look, it says, all I am is a flurry of marks made by a human hand, but look what I *also* am. Look at you, fooled by nothing but paint.

By contrast with all of the works of art discussed so far in this chapter, this painting is notably restrained in its range of colour. In fact, it's not simply that Morisot's palette is toned down: here, no colour is itself for very long. One colour sweeps into another, in a seemingly living process. That's another effect of those dancing marks: the look of a continual present tense, as though the painting is being made before your very eyes. There are few colours, in fact, that don't reappear many times across the surface of the canvas. Pale pink, light lavender, silvery greys and sparks of electric blue are dispersed throughout, in an effect that is very like that of an abstract painting. The artist makes use of accents of darker and lighter shades to build a little structure into the content of the painting – to anchor it in something seen – although the kind of seeing that's implied by all of this is much more about glimpsing than scrutinising. Compare it to the blade-sharp folds of the drapery in the Van der Weyden painting, and two different kinds of looking at and thinking about the visual world are immediately apparent. Morisot's is a world in which the boundaries between human and environment, between objects and the air that surrounds them, are nebulous, even porous; by contrast, Van der Weyden's world is rigorous, certain, hard. It's easy enough to start drawing conclusions about that, but stay with the paint itself for now; let it tell you more.

See how the bleeding of one colour into another is part of the substance of the paint. Notice that the artist has laid wet paint against wet paint, so colours slip into each other, like melting ice cream. See the way this gooey quality has a sensuality about it, something physical. This is an environment not so much seen as felt. The paint is put to work to make an equivalent not simply of the visual effect of a speedily taken-in interior but of the touch

and smell of a certain place. That misty silveriness does a lot to call this to mind, submerging as it does the woman's body into the atmosphere of the room. As did Frankenthaler, Morisot deploys colour in certain ways in the knowledge that it will speak beyond the mere subject matter. Her painting conflates the seen and the felt by collapsing the boundaries between things through colour. By using that close tonality, with colours acting as variations on a single theme rather than Frankenthaler's discrete blasts of pure orange and blue, Morisot's colour keeps the possibilities of the painting in play. Here, colour's ability to say many things at the same time is what really counts, what allows the painting to keep on speaking.

So far, we have been considering colour in art as a means of speaking to a receptive viewer beyond the limits of subject matter. There's a problem here, though: how do we know what colour we are actually seeing? The terms we use for colours are contingent on a general consensus about what those colours actually are. Above and beyond the vagaries of human sight – from colour blindness to short- or long-sightedness to all the many shades of optical difference, making the very idea of a singular 'viewer' a distinctly unreliable one – the actual colours of works of art are often highly unstable. For one, there's the fact that paint, composed for millennia from coloured matter suspended in a binder, can transform over time, as chemical reactions and the actions of the natural world cause changes that can easily switch a green to a blue, or a blue to a grey. There are innumerable cases of paintings changing colour over a century or even less, and thereby taking on all sorts of unanticipated meanings. The paintings of the Italian Renaissance painter Paolo Veronese, for instance, appear to depict overcast grey skies, a quality that found favour in nineteenth-century British collectors of his work, who saw something familiar and homely there. Little did they realise that these were simply Italian blue skies that had faded over time. They weren't 'wrong' in their interpretation,

though. They were simply working with what they had, as we all must. Colour's chemical transformation over time is testament to how artworks are embedded in the physical world, not separate from it. There's no work of art that doesn't change over time, both in its physical form and its possible meanings.

Another aspect of considering the flexibility of colour's possible meanings is in its relationship to light. Our most common experience of works of art these days is in museums, which are generally lit with overhead electric light. This bears little resemblance to the kind of light those works of art would have been made by, or made to be seen by. Consequently, 'our' red bears only a passing resemblance to the red that Rogier van der Weyden would have seen, depending on the time of day – and that's quite apart from the many times it must have been restored and repainted over the years. In his studio, illuminated by the diffuse light of northern Europe, or the yellowish glow of a lamp or candle, it may well have looked very different. Things get even more complex when we pay a visit to a work of art in its original location. Paintings in churches, lit by electric or actual candles, or a coin-operated blast of bright light, often don't look anywhere near as sharp or clear as they do in reproduction. Unless, of course, they were never *meant* to be entirely visible. Perhaps they were *meant* to alter their look according to the changing fall of light as the seasons turned. Their colours, then, would always have been unstable: sometimes bold and bright, at others muddy and dark. Whether artists of the past thought of their paintings in this way, we might never know, but the fact that the colours in a painting undergo transformations depending on where they're placed, how they're lit, and their current chemical conditions ought to be part of our thinking about them. This is one key way that a reproduced painting has an only superficial relationship with its source. A painting's organic life is measured in colour. The slipperiness of colour is part of the porousness of art, of how the world and its shifting atmospheres seeps into it.

Colour in three dimensions

In three-dimensional art, the idea of a colour being in the material or applied to it is an important element of how it works. A sculpture whose essential surface qualities remain unpainted and visible to the naked eye might bring forth certain assumptions: ideas about authenticity, or closeness to nature, or something ageless. By contrast, a painted sculpture may well come across as artificial, heightened, maybe even grotesque. In the West, an ill-informed but pervasive interpretation of the ancient past led to a veneration of the clean, white surface of marble as a kind of embodiment of aesthetic perfection against which other works of art might be judged. The colourful, the distorted or the decorated fall short by that criterion. Given we now know that most ancient sculpture was itself painted, often quite gaudily, this turns out to have been a wrong assumption to make. But art history is a story about the misinterpretation of the past as much as the continuation of it, and so ideas about colour and surface have become interwoven with assumptions and errors made about the past. This means that colour in sculpture is a fraught subject. Different aesthetic positions, which are expressions of cultural, political and social biases, have informed the making of art in every society since the beginning of recorded time. Sculpture has so often been an expression of political power – be that a statue of a deity, monarch or military leader – and material, scale and colour are absolutely primary to the nature of that expression. Interpreting colour in sculpture, then, means contending with complicated histories – and, as ever, a willingness to discard them, however temporarily, and take time to actually look at the object itself and to pick up on its tone of voice.

One way in which colour can be seen to live an independent life from subject matter is when it's deployed at odds with what it seems to depict. In naturalistic art, this distinction is harder to make: we can easily make the assumption that colour is there as

pure description. But a realistic landscape painting, made using
colours that are as faithful as possible to the perceived colour of
the scene, is as dependent upon the expressive qualities of colour as
an ostensibly abstract painting is. Certain works of art allow us to
get a better understanding of this, especially ones in which colour's
descriptive capacities seem to have been completely subverted. This
separation of colour and subject is actually a useful way of consid-
ering colour as its own language, which is at once an expression
of a work of art's intended meanings and somehow separate from
them. Think, here, of Mark Rothko, finding a spiritual intensity
in the Pompeii frescoes through their singular use of colour while
disregarding the narrative content of the paintings. In a sculpture
by the German artist Katharina Fritsch (Fig. 5), this separation
forces a kind of double-edged effect, in which the object you see
seems at once naturalistic and abstract, faithful to its source and
faithless at the same time.

As the light of day falls on the surface of the sculpture, shadows
generated by its naturalistic forms create a tonal range that opens
up ideas around colour in art in general. Placed outside, in public
space, the sculpture is subject to all kinds of variation brought on
by the changing light. If this is what it appears to be – a bright
blue rooster – how many blues are contained within that single
word? It's a reminder that our language fails when attempting
to describe the almost infinite variations hidden within a single
simple term. Already colour's propensity for slipperiness suggests
that the sculpture is speaking in several ways at once. Because of
the way we experience works of art, colour and subject matter can
seem to be intimately bound together, with colour at the service of
storytelling or naturalism. Fritsch's sculpture generates a productive
tension within this traditional way of seeing. By shaking colour
loose from description – literally using colour *against* its descript-
ive function – it's allowed to stand on its own, and might be seen
to be speaking in a completely different register from its surface.

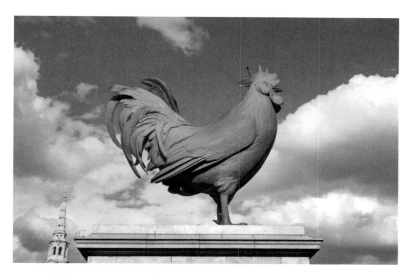

FIG. 5 Katharina Fritsch, *Hahn/Cock,* 2013/17. Fibreglass, polyester resin, paint, stainless-steel armature, 440 × 440 × 149.9 cm. The Fourth Plinth, Trafalgar Square, London

The cockerel's colour, as well as its scale, is a reminder of its distance from the real animal. What this sculpture seems to touch on is the nature of our faith in the visible world.

Colour, of course, is deeply ingrained in our sense of the 'real'. Simply compare the experience of watching a black and white rather than a colour film: the former can only ever feel like a slightly heightened or abstracted vision of the normal world, however compellingly. Dream sequences or hallucinations in cinema are often shot in a distorted or unusual colour scheme, in order to announce their distance from everyday experience. So, too, does this highly naturalistic sculpture make use of our complicated and deeply felt relationship with colour in order to explore very different ideas of what constitutes reality. This is not obscure conceptual territory: it's fundamental to much of human experience. What complicates things still further is the understanding that colour *can't* come into visual art without some sort of medium, be that the surface of a

canvas, the skin of a sculpture or the screen of a TV. So there's a way in which Fritsch's sculpture usefully reflects on the art that came before it, prising open what it is that works of art consist of while acknowledging the failure of the endeavour. What remains is the ability of works of art to speak on various different, even contra-dictory levels at the same time – or, better still, their inability *not* to. What's said of Fritsch's sculpture could just as easily be said of any work of art in this book.

Colour's ability to speak on its own is a driving force behind ideas of abstraction in art. While pattern, surface, gesture, scale and many other considerations are principal concerns of abstraction, colour seems largely central to how a kind of communication can take place if an artwork has no discernible subject. This means that the abstract language of colour ought to be considered a fundamental characteristic of visual art as practised by humans. I'm using the word 'language' here not to suggest that abstract art translates simply and clearly from the visual to the verbal. Rather, abstraction might be said to act a little *like* a written or spoken language, in that it operates within certain frameworks and tra-ditions, but, like other non-linguistic cultural expressions such as instrumental music or dance, its speech is by nature open and multivalent. This book's basic proposal about visual art – that its physical, material and visual qualities are its fundamental channel of communication – can be best explored in relation to purely abstract works of art. Looking at Rasheed Araeen's work *Zero to Infinity* (Fig. 6) might be a good way to do just that. It's an effort, sometimes, to not leap to a narrative reading when faced with representational art – it takes active work *not* to 'read' it – and that's clearly not an issue in the case of a work like this. So the question then becomes: what *is* this?

We have already seen how a very reduced colour palette can generate an interesting tension between a work of art's form and its apparent subject, in that the colour seems to steadfastly refuse

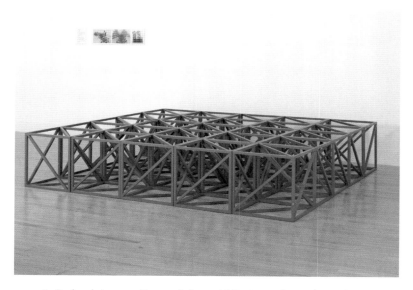

FIG. 6 Rasheed Araeen, *Zero to Infinity*, 1968–2007. Painted wood, each part 50 × 50 × 50 cm. Tate, London

to describe anything other than itself. That is especially clear in a work like this, in which a uniform blue does nothing at all to distinguish between what seem to be (and are) identical geometric units placed on the floor. One of applied colour's conventional roles, to create an inner hierarchy of parts in which one area is more significant than another, isn't at play here. The blue simply behaves, as it does in Fritsch's work, as anything blue does when it meets light: exposed parts are lighter, those in shade darker. It might cast a blue pall over the white walls and floors of the gallery space it occupies. But despite the fact that the blue intentionally fails to generate specific associations, its release from them is part of the work's apparent openness to a viewer's imaginative engagement. A photograph of this work can't express much about it beyond its form, which is austere, perhaps somewhat industrial, or even architectural. Encountering the work in real life is another matter

entirely. The artist has allowed for the components of the sculpture to be touched, picked up, moved; the entire composition of the piece can be rearranged. In this way, the non-allusive quality of that blue, that might come across as brutally reduced in works of art similar to this, is in fact a component of its openness. The blueness of the work can be transformed to the endless degree that the title promises. The work becomes a celebration of colour's possibilities in the mind of a participant. If this kind of participation might recall something from a child's toy box, so much the better. (Even its simple palette has something of the building block about it.) Araeen's invitation allows us to reimagine play as something both useful and meaningful. Remaking the sculpture's form acts as a reminder of all art's perpetual transformation in the imaginations of those who experience it. The literal generation of new forms, as the blue units get stacked up and shunted around the gallery space, is a powerful metaphor for this.

Let's take Araeen's work as a provocation to allow colour to be a site of imaginative play. Releasing colour from its descriptive role in art – a role which colour itself doesn't quite comply with, even if it's asked to – means that we can consider it as something mysterious and flexible. This is one way that works of art, whenever and wherever they're made, might be able to come alive in the minds of their viewers. This is an idea born in Western modernism that might actually be usable beyond the historical boundaries of that period. Recognising colour's own complex possibilities and conceptual force doesn't mean ignoring significant contextual frames for understanding works of art. It does mean, however, that an imaginative engagement in works of art can take a key role in how we come to experience and enjoy the art we encounter. The pleasures provided by colour aren't easily defined, and might even evade description entirely, but our sustained attention to and awareness of them is the best way of honouring their importance in our appreciation of art.

Colour into words

A photograph by the American artist Nan Goldin (Fig. 7), is a useful case in point. We might well use it to put our attention to the test. Consider, for instance, the relationship between our words for the colours in the photograph and the actual colours we're describing. The kinds of greens in the image are not only hugely diverse in their tonality – from deep emerald to pale turquoise into darker blue-greens of the shadowed areas – but their physical presences are different too. The gradations of green in the silk dress aren't imaginable as separate from the sensory experience of the object they are part of. The lightest highlights on the dress's folds seem to be accompanied by the sound of the dress as it moves, or the imagined feel of the fabric between the fingers. The flat painted wall, itself built up of complex tonal areas thanks to the hard flash of the camera, can easily be imagined as cold and slightly gritty to the touch. The experience of thinking about colour is deeply intertwined with the *medium* through which it presents itself to the world. As in Katharina Fritsch's blue cockerel, colour is always something embodied. As usual, we don't have the words to fully address this. In describing the woman's outfit, we might say 'the green dress' as though 'dress' and 'green' were two different ideas, and not one entity that we both see and feel at the same time. It's a distinction made in language, but isn't necessarily part of how we come to experience colour. As young children, sensory information about the world comes bundled together; it's only when we learn the words for things that the separations happen. Looking at art in this way can't return us to lost childhood utopias, but it can restore to us some of those experiences, in which objects, people and places are porous and one thing can easily become another.

This photograph also illustrates two basic truths about colour: that it's a function of light, and that it's all relative. In the harsh light of the flash, the surfaces of things are revealed as being not a

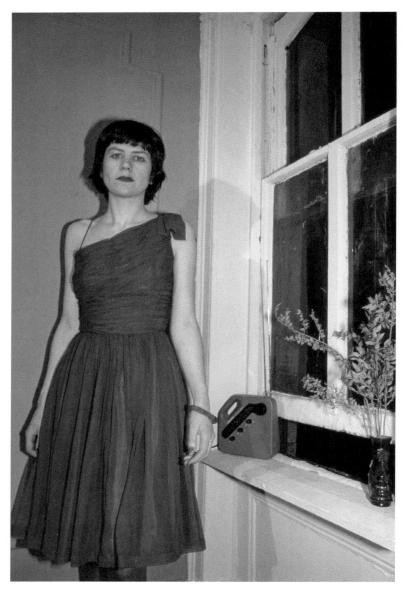

FIG. 7 Nan Goldin, *Vivienne in the green dress, NYC*, 1980. Dye destruction print on paper mounted on board, 102 × 70 cm. Tate, London

single, flat tone – the visual equivalent, maybe, of the single word 'green' – but as composed of all manner of shades depending on how it receives light. It's a fact that can be easily overlooked in everyday life, but that works of art like this one, when looked at carefully, can reveal. What this can open up for us is the idea that the world we inhabit is far more complex and nuanced than we might ordinarily take it to be. This goes for artworks themselves as it does for every other object we perceive. Paintings or sculptures that are described as being a particular colour are only that way *because* of the light in which they are seen – which, as we've seen, may well not be the same light in which they were made. A similar complexity exists around the intensity of individual colours, which is all a matter of context. In Goldin's photograph, the visual force of the many greens is generated in part by the relationship with other colours in the same field. The reds of the woman's lipstick and bracelet, as well as of the leaves of the plant on the windowsill, create an optical vibration with those greens, but other, subtler relationships are taking place too: between the blues of the radio and the shadows on the creamy window frame, or the dark brown of the woman's hair and its blue-green shadow.

These colour relationships aren't a deviation from the content of the work of art, or a secondary element of it: they *are* its content. As we know, colour doesn't live its own independent life: it always comes into the world as *part* of something. So too does colour within works of art: it's always woven into what an artwork might be trying to communicate, not something added on top. Creating a checklist of elements of any given work – colour, tone, light, for example – can be a helpful way of making sure you've covered the bases, but we also have to acknowledge that all works of art are all of those things at once. It's simply not possible to speak about them as separate things. The complexity of interpreting a work of art lies in having to take into account the many and varied ways it speaks, and to accept the fact that it will not (and cannot) only

speak in a single voice. Discussing only the identity of the sitter in Goldin's photograph, or the biblical characters in Rogier's painting, requires suppressing other kinds of visual information that the work of art contains, and with which it is also speaking at the same time. To address colour in our thinking about art is to take seriously the seductions of art, without which the artwork might not have the strange power over us it so often seems to have. And allowing colour to guide us into the work, to allow it to open up more complex interpretations through our sustained attention to it, is a means by which that seductiveness can be the route towards a deeper kind of knowledge of the things we see.

Scale

Art speaks in space

I T's hard to define what works of art actually are. For the most part, we know them when we see them. Or rather, we know them *where* we see them, as most of us rely on certain institutions – museums, galleries, universities – to do that deciding for us. If it's in a place art is usually seen, it's safe to say it's probably (though not always) art. What this means, of course, is that there's a huge amount of art that never gets this kind of institutional endorsement. Most art doesn't, in fact, just as many films don't get released and most novels don't get published. There are all sorts of reasons for that, but the fact is that there's plenty of art (and films, and novels) that doesn't seek or require the validation of the wider world. There's a lot to be said for that, given that some of the art we now accept as significant wasn't thought of that way by institutions like these at the time it was made. On the other hand, it's too easy to dismiss the art establishment as manipulative or closed-minded. Once we recognise that every work of art we see in a gallery – and especially those we see in major institutions which rely on public funding, like state museums – is there because of a complex series of decisions and arguments, with many people's reputations and livelihoods at stake, we can start to discern a faint outline of the definitions of art with which such places are working. These definitions aren't set in stone, and as authority shifts, so too does institutional taste.

But for every work of art that gets to sit inside the museum, there are many more that don't. There's a huge amount of art that we will never get to see because of this. On the other hand, it's worth thinking about the works of art we *do* get to see. Art that has lasted for centuries – through wars and political upheaval, through vast geographic, societal and cultural changes – has done so for reasons that are themselves worth probing, or at the very least taking into consideration. In short, drawing a line around something to define it as art, rather than just another object in the world, is a high-stakes business. The act of defining it as such is a way of separating it, of marking it out as something of significance. What sorts of significance works of art might have, and how we might find points of entry into them, is therefore bound up in what we even get to see in the first place. It's always useful to consider what might be hanging on the wall in place of whatever it is we're looking at – and why it isn't.

So what can we say about art, with any confidence? Here's a simple statement that might serve us well as a starting point: *works of art are things in the world.* But this, like most statements about art, is not entirely true. There are plenty of artworks that exist only in conceptual rather than physical terms, as ideas on the page rather than objects in space. However, it is overwhelmingly the case that works of art, be they paintings, prints, sculptures, video, assemblages, drawings, performances, murals, photographs, found objects, installations – or any of the other ways art can come to exist in the world – occupy actual physical space. This basic working truth about art objects means that certain claims can be made about how works of art *speak*. Let's assume this, then, in the knowledge that it's only *mostly* true: works of art speak in physical terms. One aspect of learning how to interpret a work of art means learning how to translate this physical means of expression into language. But the fact is that the physical reality of an artwork can't be 'read' in the way we might read an essay or a text on a wall. We 'read' works of

art, initially at least, more in the way we read a room, or a situation, or even a landscape. That sort of reading is a complex combination of processing the sensory information we're presented with and weighing it against our own knowledge, intuition and experience. In order to tune in to the different ways works of art communicate, we'll have to pay attention to this kind of engagement, honing in on our physical experience of sharing a space with them.

It isn't that straightforward, of course. A large percentage of works of art are not now experienced in physical space. Most, in fact, are experienced as photographs – in books, prints, postcards, web pages, on TV or computer screens, or on phones. In an art history lecture, these photographs are projected onto a screen, disembodied from any sense of scale or surface. It's not that these photographs don't do justice to the originals, as is often said: they are actually *nothing like* the originals. A photograph of a painting is to the real thing what a photograph of a sandwich is to an actual sandwich. It's common to be amazed by the experience of seeing a real work of art you'd only known from photographs, but it shouldn't really be a surprise, given this fundamental difference. The fact is that works of art, like sandwiches, aren't really reproducible in another medium. Even a video camera, which can show works of art in time by moving across and around them, can't capture the bodily experience of actually being in a room with an artwork. It's not that thinking about a work of art can't happen in the work's absence; in fact, it's often not possible to see the real thing, for reasons of geography or expense or the fact that the object in question may no longer exist. But it's hard to deny that something is lost in this distance. The work's ability to fully communicate is shrunk. It becomes a historical illustration rather than an object in the world. Unless we recognise that art's physicality is central to how it speaks to us, we'll become increasingly happy to accept photographs or projections as good enough, which means most people won't have access to what makes works of art worth their time.

So what is this 'physical language' that works of art speak, and how can we pay attention to it? To answer that, here's another *mostly* true statement: art tends to take up room in the world that might otherwise be occupied by a human being. A sculpture, even if it's flat against the floor, or composed of tiny, disparate parts, or hanging from the ceiling, takes up human space. A drawing, however small, displaces air in the space it hangs in. When we experience a work of art, we are sharing actual space with it. This physical language is anything but abstract and airy. It's about the actual, real space in which we all go about our lives. And before we even begin to interpret a work of art in a conventional way – working out what it's of, or who made it, or when – we register its scale in relation to our own. This happens before we read 'Van Gogh' on a label, or notice that it's a self-portrait, or fill in any of the other useful or useless information we bring to the experience of looking. It's what happens *before* we start 'reading'. And we register it, even if only for a split-second, even unconsciously, and even if we rarely think about how or why we're doing it. Paying attention to this moment of registration is central to making meaning of works of art.

So, art speaks in space. Stepping backwards to take something in, or moving forwards to get a better look, are both automatic, unthinking responses to a work of art's scale. When we do those things, we are already involved in making meaning from works of art. Our bodies are responding, and that response is already a way of thinking. Such responses don't get much serious attention in traditional analysis of works of art. Rather like spontaneous emotional responses to works of art, such as crying, swooning and fainting – all of which have happened, and go on happening, all around the world – physical responses to works of art are often not taken very seriously. This must in part be because they are, by their nature, hard to talk or write about. But these responses are very much worth thinking about and taking seriously, because they are part of how the conversation between artist, object and viewer takes

place. Often they're the first part of that conversation, and usually they are the part that most remains in the mind. Or in the body, as anyone with a post-museum crick in the neck will attest – which is *also* a physical response to a work of art, however annoying.

Let's consider this idea of the physical, bodily response with some specific works of art. The object in Fig. 8, for instance, is small enough to be held in the palm of an adult hand. Rather than move swiftly on to the historical information that has been attached to this object – in the form of an explanatory label – let's pause at that moment. This smallness in relation to the body of the person viewing it is interesting. The mind seems to reach out to the object. The artist can easily be imagined shaping the reddish-brown wax into the semblance of a male body. The warmth of his hands must have made the material more pliant and supple, almost like a real body. In turn, the object would have left its traces in the cracks of his skin and under his nails. In other words, there's a physical sympathy between maker and object that many viewers of the work might feel even when observing it behind glass in a museum. Whatever thoughts that might then lead onto – ideas of frailty, resilience, vitality, the way other objects in our lives anticipate the touch of a hand – it is through its scale that it communicates most directly to us now, even though it was made many centuries ago. It says something quite directly, even simply, but the thoughts it can set off seem like fundamental human ones. Scale is a language that cuts through time.

The Italian Renaissance artist Michelangelo Buonarroti made this wax sculpture somewhere between 1516 and 1519. This is information of the sort found on the label accompanying the object, that may or may not be useful. Certainly, in the face of the intense liveliness and dynamism of the object, it's hard to see how it enhances the viewing experience. Despite being made by a very famous artist, it was probably a quite unimportant object for him, the work of a single afternoon, and one of many such

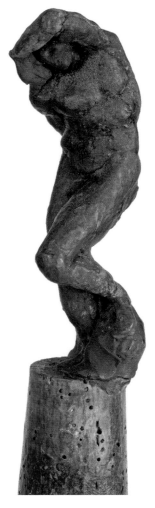

FIG. 8 Michelangelo Buonarroti, *A Slave*, *c.*1516–19. Wax on cork, 17.6 × 5 × 6.5 cm. Victoria and Albert Museum, London

workings-out in wax, a trial run for something more significant. It's certainly not one of his most famous works of art. There are no crowds jostling around it, as there are in the museums of Florence and Rome, where more famous works by Michelangelo are kept. In the museum it's housed in, you're almost always the only person looking at it. But its relative obscurity is no obstacle to its powers of communication, hundreds of years after it was made. Its smallness encourages you to move in closer, and this simple act means that the viewer's body is engaged right from the very beginning. It carries meaning that makes it more than a mere historical curio, or an unexpected survivor of a long-ago past. These thoughts about it don't emerge from an in-depth study of the artist's biography, or profound knowledge of the period: they come only from sustained and sympathetic attention.

Considerations of the scale of works of art, of course, aren't merely motivated by this appeal to the viewer's senses. All manner of factors – economic, political, geographic, theological, even meteorological – play significant roles, and we will return to some of these later. And yet it's interesting how many works of art are judged or rated on their scale, as though the larger a work of art is, the more worthwhile the queuing to see it. We've probably all met someone (we might even *be* someone) who has been disappointed by the *Mona Lisa* because it's so small. People are rarely, by contrast, disappointed by the very large Sistine Chapel ceiling. Both of these responses are about the weight of expectation and wanting the art experience to measure up to it. But the size of a work of art really has nothing to do with its quality. It has everything, however, to do with the way it speaks: its *register*, or its 'tone of voice' as mentioned earlier. This might seem an odd phrase to use when thinking about what are usually soundless objects. What's important to recognise is that scale is one of many means of expression, or registers, that artists can make use of, and it is the first, and most fundamental, of the ways we come to engage with it.

Smallness as a way of speaking

MoMA PS1 is a former primary school in Long Island City, Queens, New York, converted in the mid-1970s into an exhibition space and museum. Despite its exhibitions of international contemporary art, its previous existence remains evident. Its interior is painted in institutional ochres and greens, and the exhibition spaces were clearly once classrooms filled with long-gone children. Just inside the main entrance, embedded in shiny wooden floorboards worn smooth by generations of feet, is a small hole torn into the wood. Inside that hole, and visible only to someone leaning over or crouching down, is a small video screen, installed a couple of inches below the level of the floor (Fig. 9). On-screen, a tiny woman, agitated, seemingly nude and surrounded by flames, looks directly up through the hole. The quality of the image is slightly woozy, like a much-used 1980s videotape. Her voice is audible only as an anxious squeak. It's a work that seems to demand a small audience: only one or two people can see it at a time. Its modesty of scale and position serve only to enhance the woman's enigmatic anxiety and hellish situation. It's both comic and unsettling at once, and much of that is expressed in its scale.

This 1994 work by the Swiss artist Pipilotti Rist is entitled *Selfless in the Bath of Lava*, and is characteristic of the artist's interest in exploring the ways in which video art can speak in physical terms just as sculpture does. In other works, she has projected video onto gallery ceilings, with its viewers lying on beds, or on huge, curved screens that envelop the spectator. As with the Michelangelo, relative scale is clearly central to how her works of art speak. Interpreting these works, making sense of them, means paying close attention to our own physical experience of sharing their space. The language we might use to articulate this generally sits outside of traditional art history – we might not even use language at all, as will be explored later – but it is worth observing our own attention, which is the

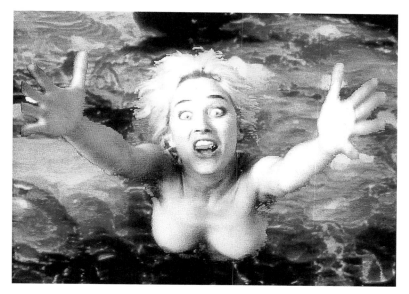

FIG. 9 Pipilotti Rist, *Selfless in the Bath of Lava*, 1994. Audio-visual installation, LCD monitor, sound system

first step in building an interpretation of a work of art. It's a step that's often skipped. Extremes of scale oblige us to notice it.

Let's consider another figure surrounded by flames, and another very small work of art (Fig. 10). While Rist's video demands a physical stopping and bending or crouching down in order to be seen, this tiny painting was made to be held in the hand or worn on a chain around the neck. In the museum, of course, it's kept behind glass, but as with the video, it can only be seen by one or two people at any one time.

Faces that look out from images make a bridge between their world and ours. Just as the woman looks up at us through the hole in the floor in direct appeal to us, so too does the man contained in this painting. It's a way for a distance to be suddenly crossed, like someone catching your eye across a crowded train platform. The power of that crossing in visual art, though, is that it can happen

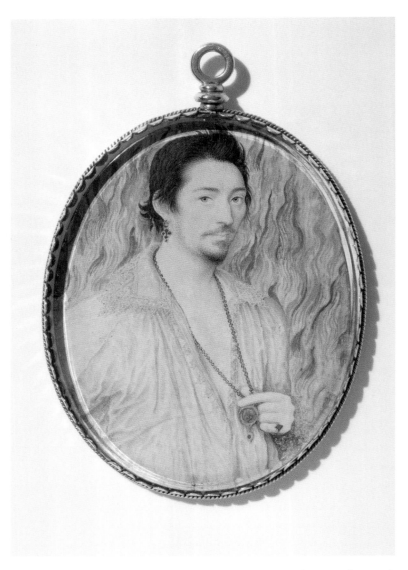

FIG. 10 Nicholas Hilliard, *An Unknown Man*, *c.*1600. Watercolour on vellum stuck onto card, 6.6 × 5.15 cm. Victoria and Albert Museum, London

across centuries of human time. It's as though history suddenly collapses, and that happens here. As he looks at us, this young man toys with a locket around his neck, which looks as though it holds a portrait just like this one. His delicate way of holding it – tender, wistful, maybe even erotic – is like an illustration of how the painting itself might have been used. Just like a photograph of a loved one in a person's wallet, this is an image of a person that may not have been looked at regularly, but nevertheless contained a tiny and important force. It is a token of a known person. The English artist Nicholas Hilliard painted this on commission around 1600. The identity of the sitter is not known, nor do we know if he was the one who paid for it to be made, which is an idea worth thinking about. What is clear, judging by its size and intimate address to a viewer, is that the scale of the painting should be central to any meaning we might make from it. Feeling its weight on a chain around the neck, and its little bumps against the chest during an ordinary day, is a way of keeping that absent person close. Imbuing an ordinary thing with emotional weight is something we all do, whether that be a souvenir of somewhere we've visited or an object belonging to someone we've lost. Children especially do this with the toys they love. That investment of extra meaning into something that, to other people, might seem insignificant, worthless or replaceable is a basic principle of how art works in the world. It's something we all seem to need to do, for reasons that feel central to how we understand our place in the world.

This way of speaking in physical terms is something almost all works of art share, and it's the particular territory of visual art. Other forms of human culture do consider the physical dimension of their means of expression – there's a world of difference among the spaces of performed music, for instance, from the back room of a pub to a football stadium – and part of our engagement with such experiences is certainly a physical one. However, visual art can't *detach* itself from the physical as easily as music or literature or

even theatre can. Novels and films don't have specific dimensions: it's the same novel whichever edition we read, or if we read it in the form of a book or on the screen of a phone. Knowing the length of a novel before we experience it might suggest something to us about its content, and might be part of how we prepare ourselves to start reading it, but it isn't much of a basis to start interpreting it. Similarly, the same film might be watched on a tablet or projected onto a cliff face, but although the experience will be wildly different, the film *itself* is the same. Most visual art, though – with the notable exception of digital art accessed via a screen – operates in actual space. It plays upon our learned ability to read space, something we pick up as we learn to cross the road or how to find the best seat in the cinema. The initial surprise of the little video in the hole in the floor isn't a fleeting sensation, to be passed over in favour of a more measured analysis: it is *part* of what the work is trying to do. So too with the Hilliard painting. It's not that its scale is *as important as* its content (the image of the unknown man); it's that its scale is *a part of* its content. You might even go so far as to say the scale, with all its implications of intimacy and longing, *is* the content. Imagine comparing the same image made as a wall-sized portrait in a gold frame, and that point should seem less outlandish and a bit more self-evident. It isn't something that can be understood in a photograph of the painting, but it's easily and quickly grasped in the presence of the real thing.

Earlier on I briefly mentioned that the person experiencing these works of art might not use language at all in their interactions with these works of art. The initial response to the video by Rist is usually not expressed in well-turned art-historical sentences. Expressions of amazement ('whoa', 'wow', and so on) are quite common reactions to it and works like it. Such terms don't have much of a place in writing about art (just like crying, swooning or fainting) but are genuine emotional reactions, even if negative or even indifferent. Finding a home for these responses in our thinking about art and

its history would allow our thinking a wider range of possibilities. After all, they are honest reactions to the physical nature of works of art. They are in tune with how artists make use of the space we share. And it is certainly the case that many works of art were made with just such a reaction in mind.

Size matters

Large-scale works of art illustrate this idea particularly well. Colossal sculpture, meaning much larger than life-size, is always experienced first and foremost as something much, much bigger than us. Its meanings emerge out of that experience of relative scale, whether it's a sculpture of a political leader, religious figure or mythological or allegorical character. The Statue of Liberty, for example, is a highly complex piece of public art whose many possible meanings emerge from its sheer scale. Before information about its content can be processed, its size and consequent visibility, especially to those reaching America for the first time by sea, is meaningful enough. In this case, the tone of voice is a public one. Its scale and formal clarity – its large, plain areas of undetailed metal making it 'readable' as an image from great distances – implies a single, unambiguous, agreed-upon meaning. Contrast it with the tiny Hilliard portrait, which is private, obscure and evidently personal, and that distinction of scale and tone of voice is quite apparent. The Statue of Liberty was constructed by many fabricators over a number of years, to one person's design; the Hilliard was made by a single artist, hunched over the object with a tiny brush. The implication of this wildly diverse manufacture might seem to be a straightforward dichotomy: the brazenly ideological public work of art versus the esoteric and ambiguous private one, say. And yet scale is misleading here, too. Just as the scale of a work doesn't imply a greater significance, it also doesn't mean a work of art is

less ambiguous, or less open to complex interpretation. The Statue of Liberty, after all, fluctuates in meaning constantly depending on when and how it's being viewed, or who by.

Making sense of Kara Walker's monumental sculpture from 2014 (Fig. 11) means moving around it, negotiating its scale in relation to one's own. Because there is no one point of view from which the work can be seen, the experience of seeing it unfurls over time as well as space. The differing viewpoints destabilise any singular meaning that might be applied to it. While its scale might suggest the apparent straightforwardness of a Statue of Liberty, the complexities that spring up if you're really looking, and really moving, help it slip out of being 'about' any one thing. Stereotypes of African-American femininity, both domestic and erotic, emerge and jostle; histories of labour, sexuality, theatre and economics come and go. Details of the work's manufacture and surface qualities – it is covered in white sugar, and seems to be carved out of a giant heap

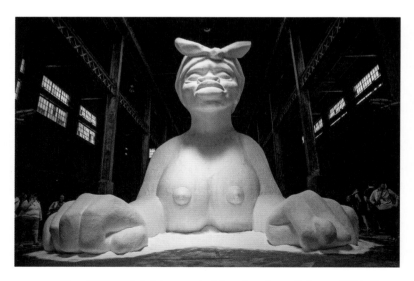

FIG. 11 Kara Walker, *A Subtlety, or the Marvellous Sugar Baby* ..., 2014. Sugar, polystyrene, plastic, molasses. Creative Time, Inc., New York

of the stuff – appear only in the physical act of movement over a period of many minutes. This unfolding in time, the accretion of visual experiences, is how Walker makes use of scale as tone of voice.

In walking around the sculpture, the figure's raised rear end and feet come into view and with them more complex possible meanings emerge. The intimacy of her exposed genitals, the tenderness of her large toes, her sphinx-like profile that appears from a certain angle: all of these new pieces of visual information demand to be taken into account, like extra ingredients added to a soup. The piece, entitled *A Subtlety, or the Marvellous Sugar Baby, an Homage to the unpaid and overworked Artisans who have refined our Sweet tastes from the cane fields to the Kitchens of the New World on the Occasion of the demolition of the Domino Sugar Refining Plant*, was made for display in a specific location, an empty warehouse near the East River in Brooklyn, New York, which once belonged to the sugar manufacturer Domino. The resonance of the site brings with it further possible areas of thought. What's more, the sculpture no longer exists: it was made to be a temporary installation in the warehouse, which itself has since been demolished. The history of sugar and its transportation to America, or the story of the warehouse's usage, or the artist's larger body of work, are examples of prior knowledge (or discreet on-the-spot research on a phone) that might extend and deepen how we process our lived experience of being with the work. But the essential register of the work is expressed in its scale, and how that might generate physical effects in any viewer willing to pay attention to their own acts of attention. Any further thinking about the sculpture will need to emerge from and circle back to the experience of its scale and presence within that space. Any interpretation of the work ought to contend with that effect of scale, and attend to the physicality of the work when considering its meanings, even when we only, and by necessity, see it in photography and film. In this way, works of art such as this can be addressed in a fuller way, beyond being presented in simply didactic terms, or as conveyers of

messages. In order to do this – to make scale central to how we think about what art might mean, we'll need to find a way to *make use of* the physical experience of being with the work of art. To marshal, in other words, the sharp intake of breath as the giant sphinx came into view in the warehouse, or as it became clear that the gnarled wax shape on the cork was in fact a human figure twisting in space.

Because all sculpture speaks in three dimensions, its territory is that of our own bodies; we share the same space. When a sculpture, such as the work by Bharti Kher from 2016 in Fig. 12, has what appears to be a naturalistic or representational character – it's

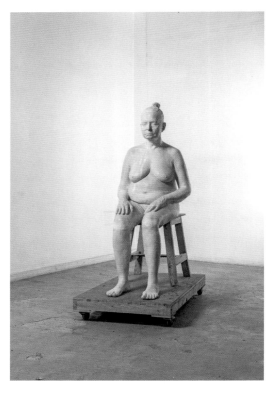

FIG. 12 Bharti Kher, *Mother*, 2016. Plaster, wood, 140 × 63 × 96 cm. Courtesy of Bharti Kher Studio

realistically rendered and is the same size as a real human body – it's almost an instinctive reaction to engage with it as we might a real person in front of us. The viewer's proximity to such an apparently lifelike (and naked) figure might be where some of the work's productive tension will lie. The all-over whiteness of the object, as in Walker's monumental piece, is a means both of allowing the parts of the sculpture to be fully visible – here, the cracks and wrinkles on the hands, the neck and the knees, those parts of the body that move most – and to set in motion associations with whiteness we might bring to the experience of looking.

The way the sculpture has registered the bodily movements of a specific person is, like the direct gaze of the Hilliard and Rist works we saw at the beginning of this chapter, a way of collapsing the distance between the object and the viewer. A sense of naturalism can do that, and the fact that this is unpainted plaster, which has been used to create a life mould of the human subject, might underscore this sense of authentic naturalism. Words might creep into our description, like 'unflinching', 'unsentimental', or even 'objective'. Such adjectives, often used within writing about art, are always worth carefully dismantling in order to consider their working and trace their origins. It's a productive thought process, since so much figurative sculpture rests on this idea in a broader sense. 'Realism' within art is always something to handle with care. In a public sculpture of the sort that sits on plinths all over the world, the political or religious reality of the subject, be that a monarch, a politician or another figure of consequence, is embodied in the sculpture itself. They are presented, through the choice of certain materials, and by being placed in a particular location, as *more* real (meaning more consequential, more historically resonant) than the actually real people who pass them by on a daily basis. What complicates this is that the real people these sculptures depict are themselves invisible, either through having died, or by being physically remote from the public sphere. The investment of belief in their realistic

effect is absolutely central to how these objects function. Bharti Kher's cast of her own mother's body operates in the same context. The real, living body the life cast is made from must be physically absent for the work to be completed. Considering ideas of the real, the visible, the present and the authentic allow our ideas about the work to deepen and resonate, perhaps in our own life experiences. The scale of the work is the vehicle for these thoughts to emerge.

Kher's sculpture uses the naturalism of actual human size as the basis for a viewer to form ideas, to think about presence and absence. The same might be said of the Kara Walker sculpture, whose sparkling sugary surface, used at a colossal scale, complicates our sense of its monumentality. Just as the physical is a special territory of visual art (with some exceptions), by extension the viewer of a work of art is always an embodied one. When we say 'viewer', then, we ought not to be thinking of a single immobile eyeball fixed in space, but rather a mobile physical entity capable of experiencing art in all sorts of ways that go beyond vision. Since all bodies differ, there is no single way of experiencing art. The conversation that takes place – the conversation that is *where* the art experience actually happens – is between the body of the person viewing and that of the art object itself. That is true if the work is held in the hand, glimpsed through the floorboards, looked up at in a cavernous warehouse or spotted, beyond the waves, from the pitching deck of a boat bound for a new home.

The size of paintings is often related to the kinds of rooms they were made for. Huge paintings on the walls of art museums generally suggest that they were made for correspondingly gigantic palaces or churches. Vast paintings made to sell in cavernous commercial galleries require buyers who themselves live in expansive (and, obviously, expensive) homes. It implies something about the rooms they were made in, too: only certain studios can accommodate very large paintings, which probably implies a certain level of professional success on the artist's part. Yet it's not only a painting's economic

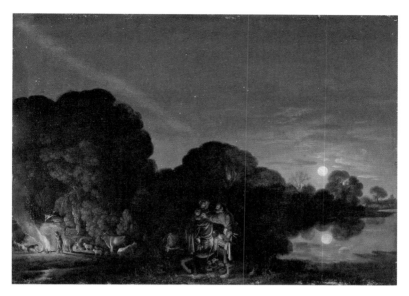

FIG. 13 Adam Elsheimer, *The Flight into Egypt*, c.1609. Oil on copper, 31 × 41 cm. Alte Pinakothek, Munich

circumstances that can be assumed from its size. The work of art's *tone of voice* mentioned earlier is communicated firstly through its physical dimensions. The size of a painting is already saying something, in other words, and tuning into that way of speaking can generate ways of thinking that go far beyond what the work of art seems to be about, and dramatically enhance our engagement with it. When a painting is relatively small, such as Fig. 13 – which is about 30 by 40 centimetres, not much bigger than a magazine – it is already drawing us in. It's a matter of paying attention to what that kind of scale might suggest, and how our physical negotiation with it might be at the core of where our thoughts go next.

A central question when thinking about the implications of the scale of any given artwork is about viewership: how many people can see this work of art at once? The Nicholas Hilliard portrait is really only viewable by one person at a time. The Statue of Liberty can be seen by thousands. A printed poster, photograph or image

distributed online: possibly millions or more. This question is part of our initial thoughts about tone of voice. It might even be compared to a literal voice, whispering and delicate for the Hilliard, or loud and dynamic, like a speech at a political rally, for the Statue of Liberty. We're already starting to think about the kinds of meanings that might possibly emerge from our attention to the work of art, before we even begin to address other aspects. Obviously, it's clear that anyone seeking to make a work of art that speaks to an enormously diverse and complex viewership is more likely to go for the monumental public statue rather than the locket-sized painting held in the hand. This painting, then, immediately establishes its voice through scale. It's small, but not as small as the Hilliard: so on a scale from hand-held painting to Statue of Liberty, it's nearer the bottom end. It's a quiet, toned-down kind of voice. We lean in to get a better look. Our closeness to the object seems to require our own quietness too. If we're standing in front of the Statue of Liberty, trying to tell a group of people what it means, we might well raise our voice, or flail an explanatory arm about, to make ourselves understood. But here our quietness, and bodily stillness, is what's called for. Our own quietness and stillness becomes a kind of theme within the painting, too, so that our behaviour in looking at it gets reflected in what the painting shows us. We're looking at a night landscape with different kinds of light – moonlight, lamplight, firelight, starlight – making discrete pockets of quietness in different parts of the scene. Each light source is about different sorts of closeness: the intimacy of a family group, the warmth of a fire, the impossible distances of the stars and the moon. This means that our physical closeness can become bound up in complex thoughts about the nearness or distance of things. Adam Elsheimer, a German artist, painted this in around 1609. The biblical scene it refers to, known as the Flight into Egypt, is about relative scale too: the birth of a tiny baby and the huge spiritual and political implications of that event. Regardless of our religious beliefs, these are ideas that

many viewers, standing almost near enough to touch the painting's surface, can find meaning in.

This kind of approach could apply to any work of art we encounter, and because it's based on using our own bodies as a kind of measurement, it's something anyone can do. Vast portraits of monarchs, often found on the walls of stately homes, operate firstly at the level of scale: the relative scale of the painted body and the viewer's own establishes the tone of the painting's voice. Similarly, a contemporary drawing the size of an A4 sheet of paper sets up a certain relationship with any viewer's body and their experience of objects in the world. These scales allow us, in the face of works of art that are unfamiliar to us, to make comparisons with known things, and by doing so to draw the art into our orbit. This photograph might be the size of a pool table. That sculpture might be as big as a bottle of ketchup. This installation might be about the same dimensions as a hospital waiting room. Rather than dragging us away from engaging with the artwork, these analogies enable us to find points of contact between our lives and the object. And since all of those objects (pool table, ketchup bottle, waiting room) are scaled to a human body or bodies, our understanding of how the work of art is speaking can be drawn directly from the knowledge we ourselves bring. It's a question of making use of that knowledge and of trusting its ability to generate meaning. In this way, our experiences of engaging with works of art can reflect back onto our own lives too.

The scale of a work of art also implies something about the conditions under which it was made. A small and highly detailed painting like the Elsheimer is likely to have been made by one person, making minute strokes on the surface with a tiny brush. The painting may well have rested flat on a table to allow for those details to be picked out with a steady hand. Given the lack of electric light in 1609, and the unreliable, flickering light of a lamp or candle, the making of it would have been closely dependent on

the available illumination in the artist's studio. This night scene was probably painted in broad daylight. These are all imagined conditions, of course, based on the only evidence available: the painting itself. But the intimacy that the painting's scale and its content suggest must have been part of the experience of making it, too. The painter's own body, bent over the work, must have felt some resonance with the relative smallness of the figures in the painting. It is difficult to imagine that not being the case. This is an important way in which a work of art can act as a kind of conduit between an artist and any given viewer. Scale enables us to imagine the experience of making. This can provide a more acute insight into the artist's practice than historical data about the artist and the work that might be provided in a written text. Reconstructing the space of the studio, and the actual experience of making, can draw artists nearer to our own lives, even ones that died long ago. The point is not about historical accuracy, or being able to find pieces of data that prove things to be the case. It's about providing a means of access for modern audiences that may not immediately gravitate to works of art of this age, or depicting a subject like this one.

Not all artworks are made under such intimate conditions, of course. Large-scale works of art are of necessity usually made by a team of makers, which may or may not include the artist, as was the case with the Statue of Liberty. The artificial quietness and solemnity of a museum interior in no way reflects the noise of the cavernous workshops in which large-scale paintings and sculptures were made. When faced with a huge sculpture, for example, restoring it to its imagined place of origin is another way of establishing a sense of its tone of voice. If a work of art is the work of many bodies, it can, even hundreds of years later, retain some impression of that context of collective labour, even if made under the specific instructions of a single individual. Our thinking about such works of art might productively take in those conditions. Just as the stillness and silence

of Elsheimer's painting seems an extension of what it was like to actually make it, so too can a large sculpture like Kara Walker's sphinx, made by a team of skilled fabricators in a hangar-like workshop. The history of that sustained collective effort might enable us to open out our ideas about sculpture and public life, or the work of art in the context of other kinds of labour. Again, this way of thinking is not about establishing a fixed or stable meaning for any given art object: it's a means of expanding how we come to interpret works of art, not as images but as events interwoven with people's real lives and experiences. Anyone who's been awed at the complexity of a medieval cathedral will understand the power of that knowledge, and how the scale of a work of art says as much about real human time as it does about size.

Scale and time

The way time and scale speak to each other in the context of art is not simply about how the size of a work of art implies a certain investment of time spent making it. It's also that the viewer's own time is required to actually take it in. Kara Walker's sculpture relies on this to generate some of its effects, revealing additional information – more views, more possible ideas – as viewers circle around it. Again, as in a cathedral, the artwork is an event in time: it can't be captured in still images. Walking through the interior of the building means our understanding of it is continually shifting as new information – a stained-glass window we hadn't seen, or a sculpture that wasn't visible before – comes to our attention. Scale, then, can be a way in which a kind of complexity can be built into the work of art. Whereas the Elsheimer could be, in theory, taken in at a glance – not that you'd get much out of that, but it's possible, at any rate – with many large-scale works of art that kind of cursory looking simply isn't possible. A 2009 work by

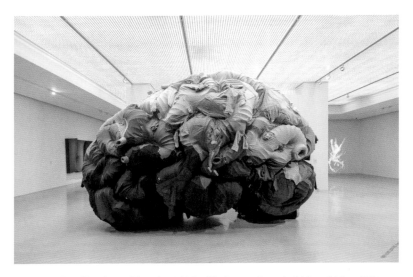

FIG. 14 Yin Xiuzhen, *Thought*, 2009. Clothes and steel, 310 × 510 × 370 cm. Courtesy Arario Gallery, Shanghai

Chinese artist Yin Xiuzhen, entitled *Thought* (Fig. 14), is a case in point. Experiencing this sculpture is a matter of passing through different degrees of closeness to the work, each one of which, as in the cathedral interior, shifts our understanding of what it is we're actually seeing.

At a certain distance – that of the standard photograph of the work – the object has a kind of neatness of outline. It is, initially at least, an off-kilter semi-oval blob, placed on the floor of the gallery space, in a range of blues graded from dark at the bottom to light at the top, as though to imitate illumination from above. It's unmistakeably the shape of a human brain. The sculpted brain, true to the form of an actual one, is made up of curving, worm-like segments, each one of which – you're a little closer now – is made out of a slightly different material, so that, clearly, the colour of the object was already part of each individual material; it hasn't been applied. A little closer, and those material parts are revealed to be

clothing, mostly shirts and dresses. The scale of the sculpture in relation to a human viewer, then, is implied within its component parts, since items of clothing always refer to an absent human body. What looked like a careful demarcation of parts at a distance becomes, at close range, a tumble of invisible bodies. Not only does the scale of the work imply a certain kind of collective effort: its component parts are also embedded in the specifics of ordinary human lives. The revelation of these different kinds of associations becomes possible only because of the sculpture's scale. It's as though new possibilities are released gradually over time, with the graphic image of a giant human brain recalibrated through close attention to its construction. A further revelation comes about when you actually step inside the sculpture, which visitors can do, one at a time, via an aperture at the back. From inside, the intricate internal structure of the work, with leaf-like ribs used to generate the curvature of the outer shape, produces yet more interpretative potential, and botanical or architectural metaphors start to sprout forth as the viewer is bathed in blue light.

The process of taking in this additional information, revealed over time through the movement of a body in space, is the quintessential process of actually coming to terms with a work of art. It's a matter of one's perceptions continually shifting, of thoughts and ideas being checked against experience. While this is clearly enacted in the experience of Yin's work, it's fundamental to all engagement with works of art. The more attention you pour into the work, the less certain you can be of it being about one thing. Time breeds new meanings. Consequently, when works of art are spoken of as having a singular meaning, it's usually the case that the speaker hasn't spent enough time actually looking at the work. Yin's sculpture's imitation of the shape of the human brain, scaled to the size of a small room, allows it to stage ideas around the complexity of human thought and its shifting in time and space. A work of art that you can physically enter clearly has certain advantages when

it comes to generating unfolding meanings. But the activity of moving closer, stepping back and moving around can be carried out with almost any work of art. Activating the body as part of the looking process can stimulate all sorts of unexpected thoughts. It also encourages us to consider other forms of human intelligence that come into play when we engage with works of art. The fact that some forms of physical engagement can't really be translated into language – the feeling as you enter the blue-bathed space of the sculpture's interior, for instance, or the sensation of being surprised by the video embedded in the wooden floor – ought not to downgrade them. Not all human experience can be easily described in words.

Encountering the work of art in Fig. 15, by the American artist Zoe Leonard, might do something similar. From a few rooms away, the space it's installed in might seem completely empty. This is a work that whispers, rather than shouts. Its relative invisibility from a distance is part of how it operates, and so, before we're even aware that there *is* a work of art in the room, it's already establishing a certain kind of tone: that of the out-of-sight, the overlooked, the barely there. At closer range, it can be seen, though not clearly: small objects are scattered across the floor. Because the artwork consists of a number of dispersed elements that aren't arranged in any clearly definable pattern, the actual dimensions of the work remain somewhat unclear. We can't be quite sure where the work begins and ends. This, like the work's relative lack of visibility, is all part of how it is speaking, which is to say, it's operating at a level of uncertainty, in which the physical presence of the art remains a matter of conjecture. The objects on the floor come across as fragile, easily broken. Negotiating the room they're in means that your awareness of your size and weight, relative to these objects, is suddenly heightened. You tiptoe around the field of objects, crouching carefully to get a better look. Already the work of art is sharpening the sensory experience of space in a way that rarely happens on an

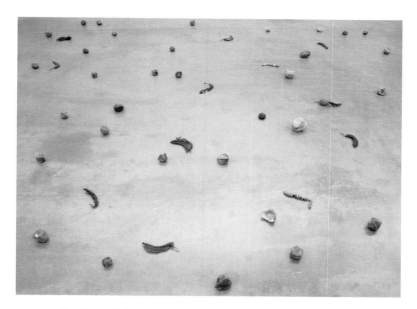

FIG. 15 Zoe Leonard, *Strange Fruit*, 1992–7. 295 banana, orange, grapefruit, lemon and avocado peels, thread, zippers, buttons, sinew, needles, plastic, wire, stickers, fabric, trim, wax, dimensions variable. Philadelphia Museum of Art

average day, unless you drop a glass and have to weave around the shards. Each object here is recognisable as a desiccated fruit skin: bananas, lemons, oranges and grapefruit. On even closer inspection it's clear that the flesh of the fruit has been scooped out and each skin has been sewn together, in variously coloured threads, to suggest that the fruit is whole again. It's an act of repair that is sometimes clumsily executed: the threads are often in colours that are nothing like those of the original fruit; loose threads dangle to the ground; some of the skins seem to be crumbling away. The attempt to make the fruits seem intact is, no pun intended, clearly fruitless, and yet the attempt is in itself somehow charming, even moving, because of its obvious failures. The flawed human act of repair is a point of contact with the work, like that bridge that opens up as the eyes of a painted face from the past meet your own.

This experience of open attention to the act of looking ought to be the basic principle of how we engage with works of art. If we allow this attention to be really sustained, our ability to build meaning from experience will be that much more successful. This means foregrounding the act of actually looking, refusing the siren call of the wall text or the groan of an empty stomach, and taking time to notice what is happening as we look. Doing this means holding certain information at bay, at least temporarily. It happens that the work is dedicated to a friend of the artist who had died. The seeming modesty of the work, its uncertain dimensions, the fragility we ourselves felt on approaching the installation, the curiosity of the stitched-together fruit skins, the decay of the piece itself – all take on a new sharpness in the light of this information. Any work of art might be engaged with in a similar way, with information brought in and weighed against the experience of the work itself. It should help us to articulate and make sense of our physical engagement with art. Rather than belittle or negate our unknowing and immediate reaction to the work on first encountering it, this information works *with* that reaction and refines it into interpretation.

Each of the works of art discussed in this chapter takes the physical experience of being in a space with a work of art as the basis for explorations of all kinds of different ideas. By doing so, they oblige us to take our physical responses to actually seeing the work seriously – especially our initial responses, even if they can't be put into words. The intake of breath as Zoe Leonard's installation comes into view might not make it into the academic essay about that work, but it's actually central to her installation's tone of voice, as something that generates a heightened self-awareness of the visitor's own body. So too the Bharti Kher sculpture, whose matter-of-fact nudity and lifelike scale provides a jolt of both recognition and, because of its lack of colour, alienation – a jolt from which innumerable imaginative journeys can receive their impetus. These are bodily responses that are part of visual art's unique territory. Its

language is that of our own experience of moving through spaces and encountering people and objects: the stuff of life, in other words. Even that sore neck, stiff back or bruised knee you take away from the museum with you is a mark of attention paid: evidence of the body as a thing in the world just as objects of art themselves are, most of the time.

Process

Making as thinking

WE aren't often aware, these days, of the way the things around us come to be made. Modern technology, such as the smartphone, hides its means of manufacture behind smooth, glossy surfaces and interfaces, to the extent that it can seem to have descended intact from another plane of existence. When such an object stops working, there's no use trying to unscrew it and fix it for yourself: you either get an expert to tinker with it, or have to replace it with a new one. This is a picture of a culture of consumption in which modern populations are alienated from the making and repair of the objects that make our lives easier. Except for the people that really do make them, their making is, by and large, invisible. Yet we all know that the experience of actually making something ourselves, be that a cake or a work presentation or a birthday card, brings with it its own rewards. A thing you've made becomes an expression of the time and attention you poured into it. It becomes charged with that experience, and your relationship to it changes. Works of art do the same thing. In order to get a better sense of where our attention might usefully be directed when we think about works of art, then, we ought to consider the act of making as an intrinsic part of where meaning in art might lie. This is going to mean not treating artworks in museums and galleries as perfect entities dropped from on high, but as (usually) final stages

in a complicated process of negotiation with matter. It's useful, then, to consider making as a kind of thinking. If we are to think more carefully about how works of art speak, paying attention to their making should become central to our engagement with them.

You don't have to be an artist, or to have taken a single art lesson, to be able to consider the idea of making when looking at a work of art. It simply requires time, patience, imagination and careful attention. Take the sculpture in Fig. 16, for instance, which is an ancient Egyptian head of an unknown sitter, made around two and a half thousand years ago. Given its realistic qualities, it's very tempting to immediately start talking about its possible subject matter, its historical setting, even its symbolism. These are all traditional art-historical terms of engagement, the sorts of things that might be on the label that accompanies it in the museum, that take us away from considering the object as, first and foremost, an object. A fruitful way of avoiding this might be to imagine rewinding time as you look at it. As history runs backwards over years, decades, centuries, the sculpture remains exactly as it is. History flickers past. After a certain point, the object is returned to its more intact state: the nose re-emerges, followed by the rest of the body, perhaps, and the setting for which it was made. Beyond *that* is its manufacture by anonymous makers in a workshop, somewhere in Egypt. It gradually returns to a coarse green stone – the stone you get a sense of, looking at the broken parts of the object. And before that, before it's excavated as a chunk of stone to be made into sculpture, it's part of the earth itself, part of huge masses of other stone, for many more years, perhaps millions. This exercise is useful for considering a number of things, not least how little of its life the sculpture has spent in a museum, let alone how short a time the stone itself has spent being art. It's also a helpful way of thinking through the decisions that have led to the object looking the way it does. While the sense of touch is generally not frequently engaged during museum visits (at least, not with objects as old

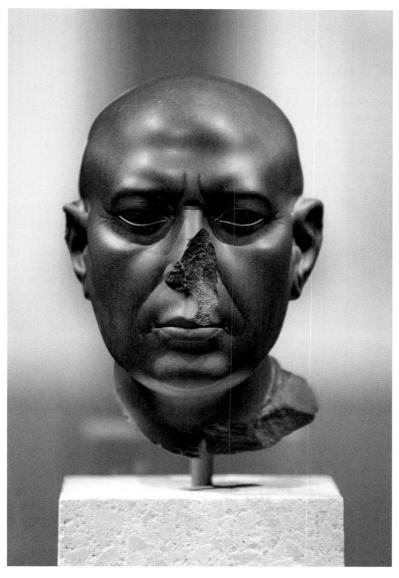

FIG. 16 Artist(s) unknown, 'Berlin Green Head', *c.*400 BCE. Greenschist, 21 × 19 cm.
Neues Museum, Staatliche Museen zu Berlin

as this one), the evidence of our eyes, working together with our sense memory of having touched comparable surfaces before, can be almost as good. This too is a helpful way of honing our visual skills. It is where visual comparisons between the highly finished surface of the worked stone and the rough original texture can be made – say, around the figure's neck, or even around the absent nose – that the physicality of the object, its weight and density, becomes most apparent. The light that glimmers on the temples and cheekbones implies the sustained labour of carving into the hard stone with what must have been, given the smoothness of that skin, increasingly precise tools. This was certainly exhausting work. The depth of carving into the curls of the ears and the full lips would have involved both strength and a steady hand, especially given the possibility of making an irrevocable error. The symmetry of that face came at a cost.

The fruit of this labour is a highly sensitive, even delicate representation of a specific human face, such that we might take the object before us *as* human, or start to impute all manner of personality traits into the subject. (In fact, it's almost impossible not to.) Such a level of engagement can take place, allowing the stone object to slip quickly and easily into the appearance of inner life, only *because* of the repetitive and draining practice of driving tools into stone. The placid calm of this head came as a result of a process that must have been physically uncomfortable, even painful, to its makers. It's not that the material of the sculpture is obscured, though, as it might be in the example of modern design and technology. Though utterly transformed, the stone itself retains a presence in the final work. This is a central component of how we might think about making in art. The degree to which a work of art's material has been transformed is an expression of a relationship between matter and mind. In this example, it might be said that adjectives you might deploy in the service of interpreting this work, which might revolve around ideas of stoicism, restraint, and

command, emerge not only from the expression of the face you see before you but also from the material itself.

Every material brings with it certain associations. Stone – like wood, glass, latex, bronze, plastic, gold, cardboard, clay, plaster, brass, iron, fibreglass, porcelain, ivory, marble, silver or any of the other myriad of materials a work of art might be made from – already carries meaning. Although these associations are certainly cultural, and much of art-historical analysis consists in tracing such materials to their economic sources, you need not have access to historical documents to get a sense of how a material can speak. It's a question, above all, of paying attention to what is actually in front of you, and of considering your own relationship to certain materials. Imagining the process by which raw matter becomes activated and turned into art is a way of getting closer to the act of making. Visualising its weight and density is part of that too. Seeing this head as the result of hard physical work frees us up to consider the experience of making, the nature of power, and human relationships with the earth and each other.

When a work of art is entirely abstract, as Fig. 17 is, thinking through its materiality can be more straightforward, as there's no representational subject to allow us to drift away from paying close attention to the object itself. In fact, many purely abstract works of art deliberately intend to draw our attention towards the material presence of the object. Some seek to emphasise the essential qualities of the material the work is made from, so that the natural look of the material – be that the roughness of clay, the sparkle of marble or the strata of ancient stone – needs to be factored into our experience of it. It's an effect that can create an intimacy between the viewer and the object, as we're not being asked to interpret the artwork in terms of symbolism or narrative, but rather, to take account of what's in front of us. In this case, a small sculpture by the Lebanese artist Saloua Raouda Choucair from 1963–5, the material of the sculpture is quickly apparent. Though the wood

here is certainly carefully worked, its grain and colouring remain visible. The artist has chosen to stop at a particular moment before the sculptural material might be hidden under a layer of paint, for instance. These moments, when artists decide to go no further in their work, are critical. In this case, it's a choice that allows the work to remain in contact with its source. The result generates the effect of a relationship between the work of art and the world that might be called organic or natural.

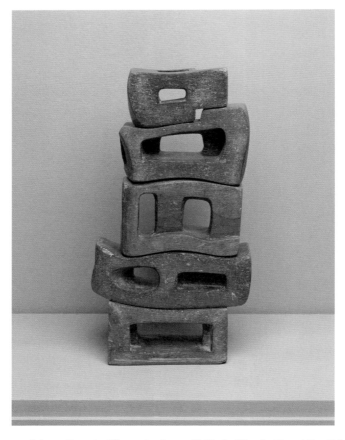

FIG. 17 Saloua Raouda Choucair, *Poem*, 1963–5. Wood, 33 × 17 × 7.5 cm. Tate, London

Despite this, the treatment of the material goes against the condition it must have been in when the artist started working on it. Again, we might think of time flowing backwards, the wood becoming coarse and splintered, regrowing its bark and returning to the forest. The care with which the wood has been carved, sanded and polished implies, as with the Egyptian head, the expenditure of time and effort. There's nothing organic or natural about that. It's a process that resembles the way wood enters our daily lives, through tables, chairs, floorboards, shelves, frames, doors, even jewellery. So our thinking about this work of art, if we're really paying attention, has to be able to take in what feel like contradictory ideas. And Choucair's transformation of the wood might take our thinking one step further. In hollowing out the component parts of the work, a little like some artists might do with stone or bronze, the artist makes the material both physically lighter and literally porous. The forms are softened, bulbous, even rather bodily. Consider the difference if, say, she had decided to make a bookcase-style stack of cubes. Making these formal decisions puts this sculpture in a very different category to the Egyptian head. The qualities that that other work seems to radiate – stability, strength, and permanence, let's say – are not ones we'd necessarily reach for when trying to describe this one. The stack of loosely interlocking parts is not at all the same as, for instance, an obelisk or column, other vertical forms that this might be compared with. Its openness, delicacy and sense of balance are all aspects of the object we'll need to take notice of. This is not to mention the associations the material brings along with it, of both vulnerability and strength, of both the transitory and the permanent, of the domestic and the collective. It's certainly possible that artists like Choucair intended for their works to generate this kind of complex thinking, which is not about finding empirical answers but holding two or more opposing thoughts in the head at the same time.

Making is arranging the world

So far, the discussion has centred around ideas of transforming natural materials, be that into a representational or abstract shape. But what happens when artists *don't* transform materials, such as has been common over the last century in art from across the world? Our first port of call when beginning to consider this idea is to think more carefully about the question. What exactly do we mean by *transform*? In both of the previous examples, the makers made choices of material that, regardless of the economic, geographical or social context that demanded they use them, brought with them certain pre-loaded meanings. These artists made decisions about working with or against the natural properties of those materials. (That, in a sense, is the story of sculpture). The transformation, then, was in some senses one of giving a new context to matter that already existed. When we see surfaces left deliberately unfinished, so that the natural qualities of the material remain visible, affecting the way we make sense of them – that is, in, essence, a re-framing of the real world as art. The work of art finds some way of harnessing these essential qualities. All of this discussion helps to build a framework around works of art that otherwise might seem not to fit into the tradition of sculpture we have sketched out. Here's a good example. Fig. 18, by the American artist Rachel Harrison, consists of some material elements that have been barely altered and some that have been, and quite significantly. Unlike the previous examples, there is no single consistent approach to materials in this work. We can't talk in universal terms about the artist's approach to the materials of sculpture. Instead, our thinking needs to be nimble. This is sculpture that seeks to energise our looking. To really experience it, we need to allow that to happen. The work of art sets the terms of our engagement.

It helps to – metaphorically, of course – dismantle the sculpture. Laying out the elements of the work against an imaginary clean

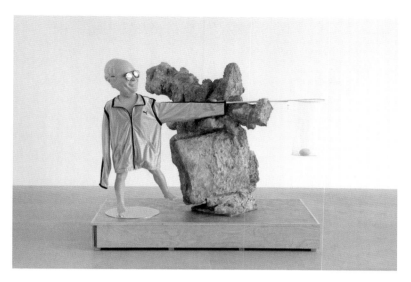

FIG. 18 Rachel Harrison, *Jack Lemmon*, 2011. Wood, cement, foam, acrylic paint, spray paint, mannequin, Dick Cheney mask, sweatshirt, sunglasses, glasses, butterfly net and plastic lemon, 170.2 × 228.6 × 83.8 cm. Institute of Contemporary Art, Boston

white surface, we can start to make groups of its component parts. One way of doing this might be by colour: things with applied colour (the multicoloured, craggy form), things that come pre-coloured (the polyester tracksuit, the plastic lemon in the net, the rubber mask, the mannequin), and things that are not coloured (the plywood base, the metal stand, the net). This isn't an exercise in cracking the sculpture like a crossword puzzle. Instead, it allows us to assess the parts of this complex work in order to think through the artist's choices. A similar dismantling and grouping exercise might be done in all kinds of ways: by the relative size of each part, by its weight, by its expense, by its strength or frailty. What emerges after this kind of careful, almost forensic assessment of the work before us is, hopefully, a feeling for the artist's choices. Gradually, we get a sense of how the artist generates internal dialogues between the constituent parts of her work. Colour speaks to colour, and shape

to shape. It's instructive to rearrange the sculpture's parts in one's head: how might it have been done differently, and what sorts of unexpected thoughts might that generate? This isn't to suggest that the sculpture couldn't have been arranged in another way: the tone of Harrison's work isn't necessarily about a kind of just-so placement, as Choucair's might be. In fact, different possibilities for its arrangement might well encourage us to tune in to the work's tone of slightly insouciant relaxation, its misleading air of not really caring how it looks.

Works of art like these aren't waiting to be solved. They are, however, waiting to be paid attention to. The inner relationships of the sculpture's component parts are not the only ones to take into account. The relationship between the sculpture and the architectural space it occupies, for example, or between the visitor's body, moving around the object, towards and away from it, are all further aspects of how it might play out. Our experience of Harrison's process, for instance, might take on new kinds of meaning when encountered in juxtaposition with a more traditional form of sculpture, or in relation to certain kinds of interior and exterior space. The same might be said of the Egyptian head, whose context of display creates certain frames by which its making might be understood. And the precision of our looking is the only route towards a precision of understanding, even if that is invariably a personal one. It's a question of accounting for what we are actually looking at, and returning to it again and again, to test our understanding of it against the physical actuality of the object itself.

Any number of initial questions might be asked of a work of art, and certain works nudge us towards them. It's a case of how artists set the scene for how we come to engage with their works. Objects of extreme scales, as we have seen, have us immediately thinking in terms of size, especially relative to our own. Elaborately made works of art encourage us to think first and foremost about manual skills and time spent making. And highly gestural works of art, such as

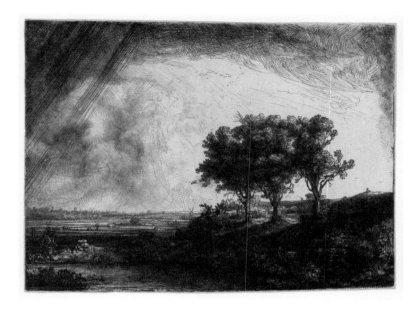

FIG. 19 Rembrandt van Rijn, *The Three Trees*, 1643. Etching, engraving and drypoint, 21.3 × 27.9 cm (dimensions of sheet). Rijksmuseum, Amsterdam

the etching by Rembrandt in Fig. 19, demand to be thought of, at least initially, in terms of the artist's touch. By no means does our engagement stop there, but it's often where it begins, and where our thinking about the work of art in question loops back to, as we consider other aspects of what we see before us and return to our first thoughts, refreshed. That initial question is our first step in coming to terms with the object, and one from which we might take any number of imaginative paths. The range of lines out of which the image is built creates a kind of oscillation, in which we see *both* a realistic landscape and its means of realisation. That might be visualised in terms of stepping towards and stepping away from the object. Proximity brings us closer to an experience of an object's making: distance resolves it into something readable. That see-sawing effect is part of what announces the work's virtuosity.

It's an image of the natural world that is very evidently one made by human hand. For our purposes, rather than reading *through* these spidery marks to analyse the image of the land, we'll focus instead on the marks themselves. The work itself seems somehow to demand it. Getting close to it, even in reproduction, is the means to make that happen.

Like any movement our bodies make through space – be that performing an elaborate dance, hailing a taxi or swiping through images on our phones – every gesture made by an artist has its own tempo, weight and direction. In the case of this particular work, a decision has been made, at some stage in the process, to allow those movements to remain visible. This gives rise to an important question in our engagement with works of art we might not have seen before: *why stop there?* This emphasis on leaving the artist's physical gesture as a visible trace is common across many works of both two- and three-dimensional art. Any work of art might show these marks, but not all artists decide to grant a viewer access to them. Abstract works of art record these movements especially well – you might think here of the dripped and poured paintings of Jackson Pollock, whose gestures of making are especially apparent to the eye – but it's no less true of works like this one, which is both a depiction of a rural landscape and a collection of complex and diverse movements of the artist's hand on a flat surface.

Paying close attention to the movements of the artist's hand will open up a work like this in unusual ways. Notice how certain areas of the paper remain relatively free from any marks at all, and are light and airy, while others are clustered and overlaid to create a greater visual density. These marks correspond pretty closely to the subject matter they're used to depict – darker areas for the knotty trunks of trees, lighter ones for the scudding clouds above. In this sense, they're illustrative marks, doing a job. But before these marks get translated into images of things, they stitch together a pattern of darks and lights that runs all the way across the paper in a kind

of visual rhythm. They work, in other words, on an abstract level, acting as a means of building up a complex visual experience for the viewer that goes beyond a straightforward rendering of a place. They also suggest different movements and positions of the artist's hand and wrist. See how the bottom right section of the image feels tightly packed and dense: that implies small movements, probably only of the artist's fingers as he grips the etching tool. By contrast, his hand is much looser in the top left, as his wrist rocks back and forth to generate those freely drawn swirls. So it's an image that packs in not only an array of tonal shifts, across a spectrum of darks and lights, but also a range of methods of applying line to surface. There's a whole repertoire of hand movements implied in what we see, as well as different techniques of engraving, each one of which has a psychological dimension too: anxious tension versus relaxed looseness, maybe. Seeing marks in this way isn't about diagnosing the artist, or making absolute claims for art's direct relationship to the subconscious: it's about being more attentive to making as something that is itself capable of carrying meaning – to allow it to mean more.

There's a kind of knowledge at work here. It's no surprise to learn that Rembrandt certainly did not make this image on the spot. That's simply part of the territory if you're using etching, a painstaking process that has to be done inside, in the studio. But no previous knowledge of that medium is needed to make that claim; you just have to look. Because the etching was made at a physical and temporal distance from the place it shows, the artist's memory, especially the bodily memory of being in a landscape under certain atmospheric conditions (storm clouds passing; wind dying down), plays a significant part in how this landscape comes to appear. It's a landscape the artist must have got to know well. Not, perhaps, as someone with a photographic memory remembers the details of a vista with perfect precision. But as someone with a particular sensitivity to his own sensory experience, and the ability to find an

equivalent for that in certain bodily gestures, might do. Rembrandt's work is a picture of a landscape being remembered through the body. That remembering can literally be seen. It takes the form of a complex network of gestures made by that remembering body: those hand movements are like movements of the mind, recollecting what it was like to actually be there. The extent to which this is a convincing depiction of a particular place is of less significance than the sensory intelligence contained in Rembrandt's act of making. The image *is* its marks of making.

This kind of intelligence in the making is by no means exclusive to Rembrandt. Even painters whose practice involves the application of precise, meticulous brushstrokes evenly spread across the surface of a canvas are thinking in physical as well as visual terms. We can think in terms of gesture and physicality for any work of art made by human hand, including works of art, like digital photography and objects made from pre-existing materials, that seem not to be authored at all. Paying attention to the physical act of making is a way of honouring the process. It's also an important means by which we can distinguish between different kinds of cultural experiences. Rather than treating an original artwork in the same way we'd treat an image of it in a book or on a screen, in other words at a distance – the kind of looking that very crowded museum spaces render more or less obligatory – we need to be able to hone our encounter by getting close. This kind of close looking, which is equally about careful scrutiny as it is about the literal closeness of the viewer to the object in question, is not often easy to do, but without it many of the experiences endorsed here can't take place.

So how do we do this most effectively? It's often a matter of reconstructing the movement of the artist's body as they set to work, as we did for the Rembrandt. With a highly gestural work of art, as in our next example, this is easy enough to do. With something more precise, there are challenges involved, not least our seemingly innate tendency to be seduced by naturalistic imagery.

Taking a realistic painting as having a 1:1 relationship with the person, place or thing it depicts is a serious pitfall when it comes to making sense of visual art, just as taking characters in fiction as real people can lead to all sorts of regrettable life decisions. It's important to acknowledge the gulf between the real event or scene and its translation on a flat surface. This need not ruin our ability to get imaginatively or emotionally lost in a work of art. But it's essential if we are to think not simply about *what* a work of art is doing, but *how* it's doing it. Reproduction, again, is an unhelpful guide to this, as most reproductions of works of art show them from the same point of view at the same distance. Flick through most art books, and every reproduced artwork is shown absolutely straight on; the same usually goes for sculpture. Higher-quality digital images that can be zoomed into are becoming more widely available, but these still treat works of art as face-on, in parallel to the viewer's body. But in almost every museum setting, or other location where art is shown, we see works of art from very different angles, and often while in motion, meaning our experiences of them can differ wildly from how we see them in reproduction. When we see an art object on a page or screen, we become detached from our physical bodies. But if we are to recognise a basic truth about visual art – that it isn't just visual, but physical too – then we are going to need to re-embody the way we see it. And if that means getting so close to a painting that its subject matter dissolves and disappears, then so be it.

Making and time

Paying attention to the marks of making, even if it requires very careful scrutiny to even see where these marks might be, means that the work of art can exist not only in space but in time. That Egyptian head we started with, if we really consider the experience

of its being carved and polished over months of labour, becomes a kind of frozen human time. Human experience of time passing, which we often fail to register and sometimes wish we did, given the speed of change in our lives, is literally embodied, made physical, in many works of art. Human time is part of all the culture we consume, from books to films to music, but it's particularly acute in much visual art because of its physicality. A two-hour film represents hundreds of hours of filming edited down in a different order. A long novel will have been edited, rewritten, re-edited; its length ought not to be taken at face value, and doesn't necessarily indicate the time spent writing it. But a sculpture or painting, if it has been manufactured by hand, shows the duration of its making more plainly. When taking in the Rembrandt or the Choucair, we are witness to time made visible, be that minutes, days, months, or even years. This might be elapsed time in the life of a single person (Van Gogh, for instance), or of a group of unknown individuals (the Egyptian head), but in any case, it's an important and poignant point of contact between the artist and the viewer, through the medium of the object. This painting on the wall: yes, it's a landscape, but it's also a day (or month, or year) in the life of someone perhaps now dead. Time is a medium of all art. All works of art will reveal this, but only if viewers themselves are willing to expend their own valuable and elapsing time actually looking. That's the trade-off.

Maybe this isn't entirely true. After all, how sure can we be that the work of art we're looking at took as long to make as it appears? Paintings that seem dashed-off and spontaneous can often be the result of many preparatory sketches and trial runs. Seemingly meticulous and detailed works of art might have been made in a sustained stretch of labour of a surprisingly short duration. And anyway, aren't we assuming something misleading here – that the making of a work of art consists *only* in the amount of time the artist spends with their brush, chisel or pencil touching the surface? Isn't a lot of artistic work about *not* making? We would have to be

pretty utilitarian in our thinking about creative labour if we only counted the literal hours of making as 'work'. Thinking, rethinking, drafting, sketching, mocking-up, modelling, trialling, rejecting, remaking and adjusting are all intrinsic to any form of creativity, not to mention wandering aimlessly, socialising, eating, drinking and even sleeping. Since making art is both a physical and mental activity, a lot of it doesn't look much like work. Oftentimes we don't get to see the early drafts of works of art – meaning that taking the object on the wall or the plinth as the repository of all the creative thinking done by the artist would be a very naïve assumption. Preparatory sketches for works of art do get shown, of course, and are for many modern viewers more appealing than the finished works they relate to. But on the whole, especially when we consider art on a global rather than Western scale, we don't see the sketches and workings-out that must have taken place behind the scenes. For the most part, what we see – be that a carved Egyptian head or an assemblage of found materials – is only one part of a much broader creative endeavour. Better, then, to treat the time frame of a single work of art as just one component in what might have been a very long trajectory of thinking (and not thinking). One advantage of seeing a large exhibition of a single artist's work is to place single works of art in a longer and more complex set of thoughts, which can recur and echo throughout a single person's life. Nevertheless, there is something of value in the idea of reconstructing the time of a work of art's creation: it allows us to get closer to the kind of thinking that happens as something is made. Strangely enough, it can make that past time feel very present, as though the act of creation were permanently taking place, in front of our very eyes.

The apparent straightforwardness of the painting by Kazuo Shiraga in Fig. 20 seems to render a discussion of how it was made somewhat moot. In describing it, some might first of all reach for somewhat dismissive terms like messy, sloppy, random, chaotic, uncontrolled, or accidental. And that might be the extent

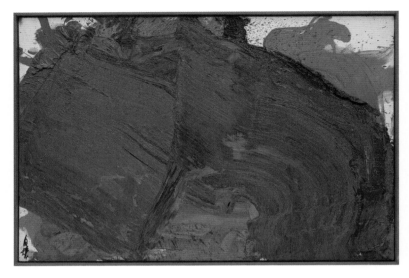

FIG. 20 Kazuo Shiraga, *Untitled*, 1964. Oil on canvas, 130.8 × 194 cm. Museum of Modern Art, New York

of the engagement. This might well be accompanied by a sense of frustration, or a suspicion that we're being made fools of. This is a common enough feeling among visitors to art galleries. Sometimes the feeling is accurate: making fools of the public can absolutely have its benefits, and there's a noble artistic tradition of doing just that. But it's really not very often the case, which means that if we make the choice to engage with the painting, we'll have to second-guess those first impressions, and test them against the painting itself. There's a value in those negative responses, any of which, if put under a little pressure, might be reframed as positive attributes of the work. We might tweak those initial responses in the light of some slow looking. Consider, for instance, the range of paint consistencies: some of the paint has been applied in thick, gloopy clumps, possibly straight from the tube, and some of it has been thinned down with some sort of liquid to create a lighter and paler effect. As our eyes crawl across the painting, the paint's qualities

resemble in their consistency all sorts of other things: toothpaste, blood, mud, coffee, plaster, soup. The artist's decision to allow the paint to be like any of these things in the mind of a viewer is part of how the painting speaks. There's a control at play here that might not have been immediately apparent at first look.

These technical choices, which must also have been bound up with the expense of actually making the work, are major contributors to the final effect. 'Applied' is probably the wrong word to use, too. The paint has landed on the canvas surface in a number of ways – flicked, flung, thrown, smeared, dragged. These are all terms that imply physical force, the weight of a human body, and that body's movements remain visible in the painting *because* of the choice of how the paint was prepared. So this is a painting in which the process of its making *is* its subject. The implication of bodily weight might well be articulated still further in the use of that fleshy red. This is a painting made by an artist's whole body, not just the hand, wrist and upper arm, as in the Rembrandt. The artist actually slid his bare feet across the surface in parts (you can see the mark of his heel in some places). These gestures retain a sense of liveness – as though they've only just been made – because of the density of the paint, and it's that impression of immediacy that the painting seems to celebrate. The artist, Kazuo Shiraga, invites us to be physically present in the time between beginning and completing the painting. His focus is, quite clearly, on how showing the process of making can communicate ideas in and of itself. Paint's ability to capture the body's movements, like footprints in wet concrete, is where the force of the painting comes from and where its ideas take shape.

Putting that process into words isn't just a matter of describing the way the work of art was made, or laying out the artist's decisions in a timeline. What's important is to see the stages of a work of art's manufacture as part of the way we might assess it, rather than treating it simply as a completed artistic expression; to

see it as an object in both time and space, in other words, not as a disembodied, frozen image. Those decisions are as much about what the artist *doesn't* do as what they do. In the case of the Shiraga, allowing the paint to skid off the edge of the canvas, for instance – not curtailing the process according to the apparent limits of the medium – is a deliberate choice that encourages us to think of it as part of a larger space. It enables us to imagine the environment of the studio in which it was made, a decision made by Shiraga that evokes a certain set of attitudes towards the act of painting itself. In such a way, paying attention to the process by which a work of art was made can be the entry point for an expanded portrait of the person who made it. This imaginative leap is not necessarily about historical accuracy; it's about building intimacy with a work of art we may not immediately respond to, which is the beginning of a deeper understanding.

Developing our engagement with works of art through attention to process is something that museums and galleries can help with. Because artists usually work in the knowledge of the art of the past and of their peers, making comparisons between artworks, especially ones to which we might not at first be drawn, can assist in accessing them. This kind of immediate comparative looking isn't possible when analysing, say, a novel, or a film or piece of music; you can only take those in one at a time. Visual art's advantage in this sense is that several works of art can be seen at once in a single physical environment. And the more works of art you see, the better your ability to get a sense of how the artist's process responds to its medium. Comparing the Shiraga with the Frankenthaler painting, for instance, might have us thinking about the various ways in which paint can be laid down on a surface, and how those ways create atmospheres of amazing diversity. Bringing the Morisot into the discussion makes the thought more complex still, generating conversations about colour, space and the human body that happen purely through one mark speaking to another. One result of this kind

of comparative looking can be a simple timeline of artistic change, which in some contexts can be of use, but the main thing it can bring is a more nuanced understanding of how artists make use of their chosen medium. Bringing in a second or a third object to put into play – even something as historically or geographically different as the Egyptian stone head we started with, or Rachel Harrison's assemblage of bizarre items – is a productive way of developing a deeper relationship with the practices of art-making. Most of the work of interpretation is done by looking hard and taking time, and you can only get better at it, the more – and consequently, the better – you see.

There comes a certain point, as we peer closely at a work of art in a gallery, at which our knowledge of how art is actually made can fall short. This happens to everyone, even art historians. Art speaks in many ways, and its technical production is only one of them. And some processes *are* highly complex and specialised. It's one thing looking at the carved Egyptian head and speculating about how it was made; that's fairly guessable, or at least we think it is. It's another thing entirely to look at a densely layered collage, or sophisticated digital animation, or intricate ivory sculpture, and be able to reconstruct its manufacture. In fact, not allowing your viewer to easily be able to reconstruct the manufacture of your work of art might well be a motivation for some artists who have made highly complex objects. Doing so can be a means of occluding the physical act of making, for reasons that are unique to each object and the time of their production.

A curious instance of this is photography. Despite the fact that the majority of us take many photographs, often on a daily basis, the actual technicalities of how photographs are made is generally considered specialist knowledge. The ease with which digital photographs can be taken and shared now, all thanks to huge leaps forward in technology, has not increased our awareness of their production. If anything, the easier the technology, the less we

seem to know or care about its means of operation. On the other hand, our awareness of what constitutes a successful photograph is a widely shared form of aesthetic knowledge. It's almost (but isn't quite) instinctive: we see a series of photographs we've taken, and we know, quite quickly, which one is best for the audience we're showing it to. Perhaps we can't say why. But many millions of us are making this sort of decision every day, as we select an image to release into the world through social media, or to share with friends. So we know, without knowing how or why, what a good photograph looks like, at least for that particular context. And we can work our way backwards from that point of shared knowledge, taking in all of the decisions involved in the image's production, in order to articulate what a photograph might say.

In art history, a photograph is an object. The fact that photographs are so easy to reproduce – they keep their basic visual qualities fairly well when printed onto a page or displayed on-screen – is maybe their greatest asset and their greatest problem. Why look at a photographic print – the actual object on which the photographic image has been embedded – when you can just as easily look at it in a book? It's true that books of photographs, often produced by artists themselves as part of their practice, tend to stay faithful to the look of the original. It can be easy enough to assume you've seen a famous photograph before, when it was only in reproduction. In current times, when photographs often remain ethereal, seen on a device or a social media site, it can be a challenge to remind ourselves that, for many artists, photographs are objects just as sculptures and paintings are. And photography is no different to painting or sculpture in many fundamental respects: scale, surface, materiality, and placement remain central elements of its expression.

The photograph in Fig. 21, made by the British artist Julia Margaret Cameron, is a large enough object that the head of the woman seems nearly the size of the viewer's own. We're used to photographs being much smaller than what they show, whether

FIG. 21 Julia Margaret Cameron, *Julia Jackson*, 1867. Albumen print, 58 × 38 cm (mount height). Victoria and Albert Museum, London

they be on the walls of our homes or the screens of our phones. The smallness of these photographs generates its own atmosphere of intimacy while at the same time putting the faces *in* photographs at a distance from our own. Their smallness is part of their sense of being *not here*. Unlike a face in a painted portrait, such as the young man portrayed by Hilliard we saw earlier, there's usually no sense of immediate presence in a photograph. In this way, photographs not only constitute our memories of people and places, but also come to resemble memories themselves: distant, reduced and partial. A cliché of cinema is to show yellowing photographs, assembled on a wall, as shorthand for a character's lapsing memory. In Cameron's photograph, though, scale mitigates against that idea. The woman's head really does have a vibrancy and aliveness that photographs often don't have. There are technical reasons for this. Working in the second half of the nineteenth century, Cameron used the photographic techniques available to her, which meant large-scale, bulky apparatus, glass plates coated in light-sensitive chemicals, and above all the need for her sitters to be absolutely still. Slowness and awkwardness were part of the process, two words we'd rarely associate with taking pictures now. But engaging with this object doesn't require a working knowledge of how it was made. It can't be reduced to an account of the scientific procedures that produced it – although early photographs like this one often are. It is an object that has all the liveness of an ongoing performance.

The uneven shape of the photograph's surface, and the blemishes and scratches that can still be seen on it, drag the object into the circle of familiar items. Like a crackly vinyl record or a dog-eared book, it bears the marks of having been passed through human hands, either in care or indifference. This is part of its effect of embodiment, although it can't have been planned by the artist. Its brownish colour seems of a piece with this sense of being antique. Again, this is an effect that was out of the artist's hands; and yet, because history is made in the present, it can't help but become

part of how we understand it. But the woman's face, centralised in that brown field and emerging from it, feels both of that time and somehow of ours. The photograph's force rests on that see-sawing, between the distant past and the living present. The depth of the image's space is little more than that of the woman's head, and there's no visible background through which our eye might escape. But even within this shallow space, like the interior of a closet, the camera's eye sharpens its focus at certain points: namely, the features of the woman's face. The curls of her hair, which fall out of focus, are made by comparison secondary, things you might not look at very closely. The lens of the machine that made this, then, acted in imitation of a real human eye. It's as though the penetrating gaze of the female subject was mirrored in the camera's own gaze and that of the artist behind it. What's staged here, then, is the act of attention itself. Our own viewing eyes are obliged by the narrowness of the focus to act in imitation of the woman's own. We too look hard and unblinkingly into the face of a stranger. Yet, like any photograph, the truth of the image is misleading. The woman whose face seems close enough to touch, whose lips might at any moment move in speech, is long dead. Her vivid appearance before our eyes is a trick. Like a fictional character who seems utterly alive to us, this woman is a construction of the medium. The hero of the story is, after all, built out of words. But as much as we remind ourselves of this – it's just stone, wood, paint, chemicals – the reality of how this construction can affect a viewer can't be played down. It really *is* as though she's there, in front of us. The fact that she seems both absolutely present and completely distant is the contradiction at the heart of what photography is. The medium itself, beyond its complex technical intricacies, has an evocative power that can affect a receptive viewer despite their being aware that what they are seeing is as fictive as a folk tale.

The focus on the manufacture of works of art can be quite alienating for some audiences. An excessive attention to the intricacies

of any given medium can come across as insular, even a little nerdy, creating a barrier of understanding between those in the know and those outside. And yet making art belongs to the universe of ordinary human experience. We only have to expand our reference points to be able to empathise with how artists deal with matter. For example, we might never have made an oil painting, but we may well have cooked a pasta sauce before, and so we have a bodily experience of thickening a paste that we can draw on in order to gain an access point to how paint is made and how it feels. We might not have carved a sculpture, but we might well have dug holes in soil, or put up a shelf, or made a snowman, or changed a tyre, all interactions with physical matter that could be mobilised in our thinking about art. It's a matter of being ready to make use of our everyday experiences, as imprinted in our bodily memories, and by doing so allow them to be of use to us beyond their simple functions. This is knowledge we all carry around with us all the time: it requires nothing of us but the will to make use of it.

Placement

Site and meaning

THE monastery of San Marco in central Florence is a complex of buildings of which the most celebrated is its beehive-like sequence of plain monk's cells, each one of which contains a single painting. The noise and activity of the square outside works in the building's favour, making its peaceful calm that much more apparent as you step inside. For centuries, monks lived and died here: it was almost their entire world. They walked its cloister in silent contemplation, assembled for meals and prayer, and otherwise spent much of their time in their cells, each of which was bare, aside from two things: a window overlooking the cloister, in some of them, and, in all of them, a fresco painting on the wall. This method of painting, which involves mixing raw pigment into watered-down plaster, meant that the paint was absorbed into the wall itself rather than sitting on top of it, so that it became literally part of the structure of the room; each painting was absolutely woven into the bodily life of the occupant of that space. In an important sense, the painting and the room are one and the same. Each one, painted by the artist monk Fra Angelico and his assistants, shows a subject that is attuned to the experience of the room itself. Religious scenes are reduced in content to their essential components, the better to provide a route to contemplation that might last a whole lifetime. The aesthetic of the paintings is spare and unfussy. They are quiet in emotional tone. They whisper.

FIG. 22 Fra Angelico, *The Mocking of Christ*, *c*.1440. Fresco, 195 × 159 cm. San Marco, Florence

Entering the cell shown in Fig. 22 as a modern visitor is to have the curious experience of trespassing. It's a small room, which holds only a few visitors at once, but it was designed for a single occupant, and its painting for a single viewer. The painting's curved shape is very like that of the room it occupies, and the artist has added illusory shadows that suggest that it's a real space, like a separate room visible through an archway. The light within the painting falls from a single source, more or less where the real window is. Figures within the painting adopt attitudes of quiet contemplation; one reads, the other holds a hand to her cheek. Behind them, a blindfolded figure on a throne is attacked by disembodied assailants, yet the atmosphere, built up through delicate colour relationships, is emotionally restrained. All of these strategies are means of making the border between the painted and the real ever more

porous. The fact that the fictional architecture is very like that of the room itself – and in fact, that of the monastery in general – is something shared by the paintings in the other cells, entwining works of art and the physical space they live in. To hear the toll of the church bell through the window, and the sound of other voices in the corridor or cloister, is to experience art as something inextricable from the inhabited world around it, whose meanings and implications draw from and are strengthened by the actual, physical space we all share.

Works of art make a virtue of this physical space in the context of an increasingly disembodied and virtual age. If we accept this as a given, we ought to take it a step further, and actually pay attention to the way works of art speak in physical and spatial terms. Being physically *in* the world, for both a human and a work of art, is going to involve a certain amount of transformation *by* the world. And to really engage with what artworks are, we'll need to accept that the physical environment in which they sit ought to be taken into account when we start to think about what they might mean. Art's environments differ wildly, of course – from the traditional museum to the artist's studio, from the public plaza to the collector's home, from the commercial gallery space to the walls of an ordinary street – but what unites them all is that they bring with them certain expectations that inflect the way we experience the art they contain. None are neutral; all are highly, and differently, charged. And in order to enhance our enjoyment of the art experience, paying particular attention to the physical conditions in which art exists is essential. What this means is that we start to see works of art not as something on a higher plane to our everyday lives, but as deeply intertwined within it. Rather than seeing the 'art world' or the 'gallery space' as a rarefied zone, we should break open those terms, accept their relationship with the rest of human experience, and make that a central part of how we come to understand and enjoy the art we see there.

A good example of this might be the interior of a Christian church. In most churches, as in many other kinds of religious spaces, paintings and other images, sculptures, stained glass, furniture and ritual objects are placed in particular ways to generate certain kinds of meanings. These places may be fixed, but the position of the viewer is not, and affects which objects are seen and how, meaning that a huge variety of shifting combinations emerge for the attentive viewer. Looking, of course, is only one part of how interiors like these build potential meanings. Sound, touch and smell are highly significant factors in how religious sites express ideas and communicate to their diverse audiences. A lot of this communication, of course, can't be orchestrated; sensory stimuli are unpredictable things. And so works of art, like a painted altarpiece in a church, are embedded in complicated multi-sensory frames that change as the viewer's body moves, or as the time of day or the seasons change.

Something similar might be said of a museum installation that rarely gets rearranged. Many museums retain the same layout of works of art for many years, which are carefully planned to communicate certain ideas about the collection itself – its historical comprehensiveness, for instance, or the quality of its holdings. Similar strategies to religious spaces might well be deployed in the design of art galleries, and it's fairly commonplace nowadays to hear galleries and museums being described as chapel-like. There's some truth in that generalisation. Both use architectural space for rhetorical ends – meaning that the physical layout of the buildings articulates certain ideas in and of itself. Entering a gallery, museum or religious building from the world outside means experiencing a transition into a different sort of space, which is often expressed by a change in the volume of your voice or the speed of your step. That adjustment is an acknowledgement of the distinction between the two spaces, and suggests a kind of preparation for a different experience, perhaps religious or artistic communion, or

even enlightenment. The reverential hush that often falls on visitors to buildings such as these is the most obvious outward sign of this. Light, both natural and artificial, is used in these settings to make sense of the large interiors and the objects they contain, and to move the people within them in certain useful ways. The architectural settings elevate the objects they hold: they are placed in particular ways to enhance their aura of uniqueness, and their separation from the ordinary world outside the building. At the same time, the objects justify the existence of the building itself: it is a container for the objects and the people who wish to see them. This means that the significance of these objects lies both within them and outside of them; both in the object, and in the spaces they inhabit. To really think about what works of art might mean, and to enhance our viewing experiences, we need to take in both at once, and allow them to affect each other. This means both looking *at* the works of art we see and looking *around* them, and not just looking, either: all of our senses need to be activated in order to fully engage with the physical experience of art in real space.

In practice, though, how does this work? Are we *really* supposed to factor in the body odour of the guy standing next to us as we contemplate a Jackson Pollock painting? Is the sound of your stepdaughter's mobile going off *really* relevant to the experience of looking at an ancient statue? Well, yes and no. The visual stimuli presented to us as we look at a work of art in a dedicated space are potentially overwhelming, from the colour of the walls, to the floors, to the frames, the lighting fixtures, the wall labels, the seating, the other works of art in view, not to mention the other visitors, and that's all before we even *begin* to discuss how our other senses are bombarded as we try and take in a single work of art. Even a minimal gallery space will have been carefully calibrated to generate an effect of neutrality, an effect that feels less and less neutral the more you notice it. No art spaces are ever neutral, of course, perhaps least of all the places where we most often encounter works

of art: museums. They bring with them a host of assumptions and expectations, and intend to deliver certain narratives that embody the reasons the museum even exists in the first place, be that the prowess of a collector, the wealth of a nation or the might of an empire. Being attentive to how these narratives are conveyed is part of being an engaged viewer of works of art. It's active attention, not passive looking, something that works of art require in order to remain culturally alive. The more things we take into account in our experiences of artworks, the more they might be able to speak to us. It's not about reducing the works of art on the walls of museums to mere expressions of power (though they can certainly be that, and often are): it's about multiplying the potential of means of access for a switched-on viewer, which means anyone who's really paying attention.

But artworks from the distant past can be intimidating to viewers who aren't used to them, and museums themselves have their share in this. Works of art made over a hundred or so years ago tend to be housed in museums built in the nineteenth century, which were constructed with a view to enlighten and edify their audiences by means of their collections. Museums of modern and contemporary art, though usually very different in design, have a similar intent, though it's generally more discreetly expressed. But nowadays, our enlightenment and edification can come from all sorts of other cultural sources, from TV shows to public figures, and we don't generally look to works of art alone to provide that sort of thing any more. But the museum *buildings* are usually still the same, and something of that attitude of art being good for you remains as a kind of hangover. It's not the art's fault, most of which was made long before anyone even thought of building a museum. But it is where the art for the most part lives, and so to really engage with artworks of the distant past, we're going to have to deal with the museum experience too. One way of doing this is to think of the museum itself as an interpretation of the art it

holds. It's a kind of framing device, creating an atmosphere suggestive of seriousness and solemnity that, at one time, was thought to be just the right one for works of art. Already, before we've even reached the work of art we're here to see, we can consider this idea as a creative interpretation, especially bearing in mind that many older art objects are very far from serious and solemn. Picturing the museum's collection displayed in a different setting is a good way of testing this interpretation. Imagine its paintings and sculptures displayed in a nightclub, or on a beach, or lining the walls of a grimy alleyway. These are ridiculous suggestions, of course. But as thought experiments, they allow us to really consider how the museum's architecture itself interprets the art it holds. It creates a certain set of expectations that the artworks themselves are often presumed to share. But close looking at and open questioning of works of art, no matter their date or origin, can sidestep these expectations.

The art of noticing

In large museums, many of us get used to ignoring things that seem extraneous to the experience, by honing in on that painting we've come to see, to the exclusion of everything else that surrounds it. Isolating works of art in this way is a natural impulse, and one which allows us to pour our attention into that particular object. We might stand still in front of it, staking out our position, refusing to budge for even the most dogged selfie-taker, as we wait for the object to do whatever it is artworks are supposed to do. It's never clear, though, how long that wait should be. Art industry insiders often bemoan the short amount of time the average visitor spends looking at works of art, despite the fact that those in the know tend to spend much less time actually looking at the objects they seem to know so much about, this writer shamefully included. A

video work will often, though not always, have a specific running time, which is helpful, but paintings and sculptures don't have those – they're just *there*. Kenneth Clark, the former director of the National Gallery in London, and one of the great popularisers of art history, once said that a viewer should look at a painting for the amount of time it takes to peel and eat an orange. Like the length of a piece of string, then, it's by definition not measurable, but it requires stillness and some concentration in order to release its pleasures.

In truth, works of art can be looked at for as short or as long a time as the viewer likes. Really sustained looking at a single object will always yield a closer relationship to it; drawing it from observation is an excellent way of triggering that kind of deep looking. It is unquestionably the case that works of art reveal themselves slowly, and whatever the object, the longer we look, the more we'll see. But that's not to disparage a shorter look, or to suggest that the only way to engage with a work of art is by spending a long time scrutinising it in detail. There's something to be said for catching a painting out of the corner of your eye. Walking past a sculpture at speed doesn't mean you haven't had some form of experience with it, however fleeting, even if it's just swerving to avoid crashing into it. And slow looking at works of art simply isn't equally available to everyone: constraints of time, access and lack of inclination mean that many people won't easily be able to have such an experience, or be aware of its value. In any case, it's by no means for certain that the objects *themselves* were made to be looked at in a slow and sustained way. There are some works of art that may have hardly been looked at at all, due to their size, function, location or ownership. There are others that would only have been looked at for the stories they told, never for the fame of the artist who made them or any technical skills that work might showcase. To modern eyes, for example, a famous painting is a Caravaggio first and a Nativity second, where

it would have been the reverse at the time of making. That shift from subject to maker is a profound and significant one, and is a result of all sorts of factors, including the rise of art history as an academic discipline, the shifting tastes of collectors and the growth of museums. Ways of looking, in other words, are very much products of their time, and there is no one stable, unchanging idea of how art should be looked at, or for how long, or from what angle. All of this is worth bearing in mind as we encounter works of art, and ought to encourage us to be freer in the way we think about them, and more confident in the independence of our interpretations.

Thinking about looking is best done in front of art, of course. In the Musée d'Orsay in Paris, the building itself creates shifting frames for understanding, enabling that sort of thinking to be made particularly apparent. Finding Gustave Courbet's painting *A Burial at Ornans* (Fig. 23) in the museum involves moving through a number of mostly open-plan displays of painting and sculpture made in the same country (France) around the same time (mid-nineteenth century), which means that any visitor, no matter how little attention they're paying, has been primed to receive the work through exposure to comparative objects. But those frames of understanding have been in play long before you actually see any art. Like many of the other major museums in Paris, you go down to go up, descending into the building before rising up through it. Whether this is a hangover of post-Revolutionary egalitarianism or simply a result of the need to manoeuvre vast numbers of visitors through the buildings, what this means is that the museum's interior acts in some ways as a continuation of the street outside, rather than – as in the British Museum in London or the Metropolitan Museum in New York, and many other examples – being raised above and away from it.

In the case of the d'Orsay, that's a product of the original function of the site, as a train station; elements of its former life are

visible in parts of the interior. In fact, once you enter, you descend still further, into an open courtyard space with galleries leading off it, before making your way into galleries upstairs. The effect of this is to suggest a kind of interplay between modern urban experience and the art gallery's interior, the division between which was collapsed in the subject matter of many of the Impressionist paintings the museum owns, some of which literally depicted train stations. But subject matter is only a small part of what a work of art is. It would be rash, however tempting, to see the museum interior as equivalent to the kinds of bustling urban spaces you see in paintings by Manet and Monet. The collection's cultural and financial value (there are many very famous paintings held there, hence those crowds you had to snake through to get in) is actually at odds with that spirit, and there's little of Parisian street life in the d'Orsay's rather austere and reserved interior design. So the museum already sits on a kind of balance, between the rarefied and the quotidian. That's a common position for museums to be in, and negotiating that balance is a full-time job for any major museum administration. The d'Orsay, as opposed to, say, the Louvre – whose collection of grand, dramatic narratives was for the most part owned by the wealthiest 0.1 per cent of society in the time the art was made – owns many works of art that are notable for *not* being elevated in their subject matter, and which were generally owned by middle- and upper-middle-class collectors. As a result, this particular museum is an ideal case study in thinking about works of art as part of the world most of its visitors inhabit, not in a zone separate from it. It also goes some way towards explaining why that's a complex idea when it comes to works of art and the spaces they get shown in.

On that lower level, before you head upstairs to see Renoir, Degas, Van Gogh and others, there are a number of rooms of mid-nineteenth-century painting and sculpture. The museum's chronological hang, which is standard for museums with collections

of this size, means that you have to make your way through the early stuff first. The implication of this sort of arrangement is that the collection will gradually crescendo in quality and significance before reaching a climax somewhere towards the end. The Uffizi Museum in Florence is the best example of this sort of approach; there's no option but to walk the museum from start to finish. It also means that the collection is laid out like a conventional narrative, with the viewers as readers. This is in fact literally the case in most museum displays of this kind, as they reflect Western art-historical writing, which placed works of art in an unfolding timeline. The viewer is positioned as a finger running across a page, passively reading the text sentence by sentence. But to see this sort of arrangement as somehow oppressive, as some critical writing on museums has traditionally done, is to discredit the agency of the reader in generating meanings for themselves through the act of reading. When Paul Cézanne famously called the Louvre 'the book in which we learn to read', a quotation sometimes brought out to illustrate modern artists' engagement with works from the past, the operative word is *read*. Reading can be a highly subversive act, which can run in deliberate contradiction to the intended narrative of works of art and the spaces they occupy. We ought perhaps to reassess the act of 'reading' art, as a complex, contradictory and intensely personal one, subject to a huge diversity of sensory stimuli that generate a multiplicity of possible interpretations. This kind of 'reading' is one way in which museum visitors can interpret works of art *against* the museum's own framework. It's 'reading' as any reader of a book might understand it: as a creative act in and of itself. As ever, close attention to the work of art and its environment is central to this kind of thinking.

By not placing Courbet's painting at the beginning of the museum display, the curators and designers of the space seek to generate a sense of how unusual the artist's work was at the time, by allowing this sense of a prevailing artistic context to be

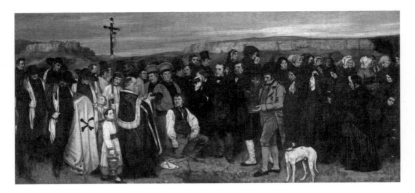

FIG. 23 Gustave Courbet, *A Burial at Ornans*, c.1849–50. Oil on canvas, 310 × 668 cm (without frame). Musée d'Orsay, Paris

set up. This approach is in line with the established art-historical narrative about Courbet and this painting in particular, which positions the artist as a kind of proto-modernist, making works that engaged with lower-class popular culture and radical politics as a deliberate flouting of convention. It isn't necessary to come forearmed with this information, though: the museum's own display provides sufficient evidence for the painting's uniqueness. It's a huge painting, but there are others of similar size installed in nearby rooms. What's really notable is that it's a large painting whose subject appears small, or better still, it's a major painting in a minor mode. But that's to consider only its subject, which is not by any means the first moment of encounter. When approached at an angle, which is the usual way a visitor first sees the painting, its presence *as an object* is immediately apparent. In the hall-like space of the museum interior, the painting is like a detached wall, slab-like and sculptural. Artificial light bounces off its varnished surface, making it only very gradually legible as a representational painting, and picking out the density of its making in swirls of thick and gritty paint. It's a reminder that this painting was made, as is true of so many works of art we see in museums, to be seen under very different lighting conditions, and so was probably never

completely visible in its entirety. Its palette, which has darkened
with age, makes the resolution of the image similarly slow. Your
eyes need to adjust to its darkness. Then, also gradually, elements
of the subject matter become visible: life-size figures, religious
costume, a crucifix, weeping mourners, a dog, a gloomy sky. An
empty grave is shown at the bottom-centre of the canvas, whose
lower edge cuts it off, meaning that it continues invisibly beyond
the painting's surface. Put simply, there is a crowd of mourners
and a crowd of museum visitors, and what lies between them is
an open grave.

 Courbet's painting and its installation in the museum are
instructive in terms of the way works of art occupy physical spaces
beyond their actual dimensions. To see *A Burial at Ornans* on
a page or screen is to miss its distinctive (but not unique) way
of anticipating the physical presence of viewers. Using life-size
figures in a painting is a means of making that anticipation clear.
Courbet's painting of a grieving crowd imagined a mirror image of
a viewing crowd, to whom the funeral bore no particular emotional
resonance, thereby casting them as onlookers, even voyeurs. In the
artist's time, that mirrored crowd would have been the urban middle
and upper-middle classes that visited art exhibitions, bought art
and wrote about it: mostly male, certainly white, generally well-
educated, definitely not the rural working-class mourners depicted
in his painting. The tension between the subject and its viewers
remains potent even now, despite the transformation of its view-
ership since then. Given this relationship with its viewers, then,
doesn't it make sense to consider the painting as *more* than just its
physical dimension? Ought we to consider a work of art's physical
occupation of space related more to its *presence* than its height and
width? As eccentric as this idea might seem, it's something many of
us instinctively understand when we hang something on the wall:
objects have a resonance, and they need a bit of space. The huge
Burial at Ornans seems to demand sufficient elbow-room to make

itself not just seen, but understood. That essential extra room – let's call it the painting's imaginative footprint – is something we might consider part of the painting itself. Reproductions can't show this, but we know it instinctively when we're faced with the painting. We move back, and that invisible footprint becomes part of the space the object occupies.

Thinking in terms of a work of art's physical resonance will require us to pay attention to what's *in* that space: the frame, the label, other people, light fixtures, and other works of art. And that's just what's viewable. As already mentioned, all of our senses ought to be engaged when encountering works of art, even if they aren't immersive installations or ones using sound or music. The sound (or even smell) of other people is unquestionably part of that experience. In the case of the Courbet painting, which sets out to monumentalise human types who would never normally have a place in painting, let alone on this scale, taking account of our immediate environment as we look is critical to our making meaning out of it. Clearly, the audience anticipated by the artist has transformed utterly, and is many times larger and more diverse than Courbet himself could have imagined. Far from shutting down potential avenues of thought around the painting, this actually allows the painting to speak beyond its moment and more clearly to ours. It's not simply that each new viewer brings new meaning to the work by finding points of contact between their lives and the painting; it's that the presence of other viewers shifts the painting's mode of address. It's speaking not to a single person, or a single kind of person, but to a perpetually changing constituency of eyes and bodies. And while there are certain inescapable facts about the painting – the artist's name, the title, the medium, the date (though, as we'll see, these aren't quite as reliable as they seem) – most of its communication is in the realm of non-facts, of the uncontrollable experience of those that share its physical space, for however long, and in whatever fashion, they decide to do it.

Art in the world

The porousness of certain cultural products, the way they can be woven into other experiences and change them, is central to how they come to have importance in our lives. If you read a novel in a particular situation – in this writer's case, *Great Expectations* during a three-bus commute, every day for months – the reading experience will be so enmeshed into that setting that the two will intertwine. The faces of fictional characters will become those of strangers you happen to notice, and the places the author describes might end up a blend of the imagined and the real. Reading is like that: the book in your hands is a meeting point between two minds, the author's and your own. Because books and especially recorded music are portable, they are uniquely placed to work like this, which might well be why more people seem to have an emotional relationship with them: they can easily mesh with other life experiences, and by doing so, transform them. This is one way in which works of art suffer by being unique: you can't take them with you. They have to be experienced under certain circumstances. Many works of art aren't even publicly available, or they're in museums on the other side of the world. Of course, what seem like (and are, at times) annoyances or impediments might be seen, from another point of view, as positive attributes.

In the course of our daily lives, we are continually negotiating space. As we move from one room to the next, or from inside to outside space, or even within a single location, we're constantly picking up on sensory clues that help us to situate ourselves within that environment. Much of this negotiation is happening, after we reach a certain age, seemingly instinctively. It's expressed in the way we instantly duck our heads when entering a smaller space, or narrow our eyes in suddenly bright light. Because these are physical rather than intellectual real-time responses to spatial conditions, words don't usually do them justice. The study of architecture as

an academic discipline, for example, is full of lists of vocabulary to describe specific details of a building's design features, but struggles to describe the sensory experience of space, which is surely a central concern of any architectural project. The same shortcoming exists in discussions of works of art that occupy three-dimensional space in a comparable way. Art that exists in the form of an installation can be accounted for in a description of its dimensions, but its actual effects elude traditional ways of speaking about art. It's not helped by the fact that most installations can't really be effectively photographed, and since contemporary installation art, like Kara Walker's sculpture, tends to be short-term, you really had to be there. It's instructive, if you *have* experienced a particular installation, to compare your memory of that experience with the photographs that survive it. They never seem to capture anything of the reality of actually being in the room with the work. (As has been discussed, this is true of almost all works of art, but photographic documentation is especially unsuited to art that unfolds over space and time, as installations do.) This means that installation art, like video art, sits a little uncomfortably in the history of art. A series of still images isn't going to serve the work at all well. Its existence as a memory in the heads and bodies of those that saw it, however uneven and unreliable that is, is a much truer account of what the work of art actually consisted of. Yet that, again, eludes the words we might use to describe it.

It's reasonable to propose that our memories of seeing works of art play a much larger role in our experience of them than art history conventionally takes notice of. It's often impossible to formulate a reaction to something we're seeing for the first time, just as we're seeing it. Words seem to fail us, whether we love it or hate it, or have no strong feelings either way, whether we're professionals in the field or first-time viewers. Often the only sensible reaction to the question 'so, what do you think?' is '… interesting'. This isn't an evasive answer, necessarily. It's actually an effective stalling

mechanism as our brains grind away trying to wrestle with the same question: 'So, what *do* I think?' Our memories of works of art are as much about how it *felt* to be there as they are about the art itself. Unless we're art critics, we generally aren't called upon to disentangle and make sense of what that feeling meant. We can quite easily go on saying '… interesting', or not saying anything at all. So to suggest that installation art suffers from not being trans-latable into a photograph is a little disingenuous. No work of art is really translatable into a photograph, because the *experience* of seeing it is by nature not something that can be visually conveyed. Images of works of art can spark memories of that experience, of course, but that's a different thing to being suitable substitutes for the actual artwork itself. Memory works best as the raw material for how art speaks to us *because* it's ineffable, mysterious and subject to decay and transformation as we ourselves change. Any history of art is really the history of various people's memories of having seen certain objects, and how those memories can, or can't, be shaped into words on a page.

Art history is full of descriptions of works of art that no longer exist. Dig into the earliest writings on visual art and you'll find many examples of very detailed accounts of lost objects, which the text itself seeks to reproduce in the mind of the attentive reader, like a false memory. This is known as *ekphrasis*, and its centrality to the history of how we talk about images is a reminder of how thin the line is between art history and fiction. Curiously enough, *ekphrastic* accounts can generate images in the head that are as vivid as ones you may actually have seen in reality. Part of this must be in the text's meticulous accounting of the object itself, and part in the yearning on the reader's part to be able to see that object in the mind's eye. Detail and desire bring the object into ghostly life. Installation, performance and video art – all aspects of artistic production that came into prominence in the 1960s and are now mainstream ideas in international art – are especially reliant on

forms of documentation that can bring them to life in the ima-
ginations of readers, since they are by nature ephemeral in form.
For artists working with these media, image and text can be one
of the few ways their works gain any kind of foothold in a broader
cultural context. But even though a text describing a performance,
or a photograph of it taking place, isn't much of a substitute for
seeing it, the work can have a kind of afterlife in the mind of an
audience engaging with these materials. The work of art itself may
be long gone, but its effects can be almost as resonant to someone
who could never have seen it. While the sensory qualities of the
original piece can't be recaptured, these effects can be thought of
as part of its imaginative footprint – meaning that the work of art
is not bound to a particular place and time, but can go on existing
in memory and imagination. Strange though this might sound, it's
something we all experience. The memory of a book we've read is
part of the reading experience; we can bring it to mind, and even
experience our emotional engagement with the story all over again
as we do. Reading isn't confined to the literal hours spent looking
at words. The same goes for our experiences of works of art, even
ones we ourselves have never actually seen.

We're on a street in Istanbul (Fig. 24). Because we're outside,
the conditions aren't subject to the same degree of (relative) control
as they might be inside a museum. As we walk, we are constantly
registering sensory events, but probably without paying too much
attention to them: the feel of unfamiliar (or familiar) pavements
beneath our feet; the need to step aside for other people; the sights,
sounds, and smells of any given urban environment. The perform-
ance of the weather, perhaps above all, can transform a work of
art's ability to speak. When we reach the work of art we're here to
see, we are already primed to engage with it in a sensory way. Art
placed outside, because it's occupying a space that might otherwise
be used for a functional purpose, or taken up by other buildings
or even other people, tends to be encountered in a bodily way first

FIG. 24 Doris Salcedo, *Untitled*, 2003. Approx. 1,550 wooden chairs, 10.1 × 6.1 × 6.1 m. 8th International Istanbul Biennial

and foremost. Unlike a classic museum experience, in which we ascend (or descend) *from* the ordinary world into a parallel space, and gear ourselves up to look at things and perhaps even think about them, works of art that sit in public spaces tend to have the benefit of surprise. Seeing this installation of chairs, we undergo a subtle but significant adjustment, from street-seeing to art-seeing. But we ought to hold onto that moment of shift and make use of it.

This work of art, by the Colombian artist Doris Salcedo, makes use of public objects: chairs. It speaks, in other words, in an everyday language. The chairs themselves haven't been changed; they're not painted, or otherwise transformed. In other words, because they're so easily identifiable, or placeable, their dislocation from their original setting is very apparent. Each speaks to particular spaces that are not like the one they've been made to occupy: restaurants, cafes, dining rooms. The artist's plain presentation of them as objects is clearly intended to call these intimate spaces to mind. What an empty chair naturally suggests is a body that is no longer there. So an empty chair is a simple way of speaking about a complex and emotive idea: human absence. And chairs themselves, with the names for their basic elements suggesting bodies – legs, back, arms, even seat – can easily become substitute bodies. They're stacked up in a deliberately haphazard way to make it impossible (if you wanted to, and some people would) to count them. So the sense of an uncountably large mass of absent human bodies might be a way of thinking about the work. But the absence is in the site, too: clearly this is an empty plot that perhaps once was occupied by a building, where people lived and worked. Filling that absence with other tokens of absence might well give the work a memorial air. Equally, though, it might not. The suggestion of communal life that the chairs themselves embody might also imply a sort of celebration. The chairs' old-fashioned craftsmanship might just as easily give rise to thoughts about manufacture, about human touch and the transformation of labour; about human relationships with

nature; about shifts in social life. When artists use objects that already exist, without altering or amending them, they open up possibilities like these. You don't even have to see the work (which has long gone from that site) to have an experience of thinking about it. It's an idea that's as portable as a song.

Being attentive to these different ways of speaking means sharpening our sensory experience of place and object. Experiencing a work of art out of doors, as in the Doris Salcedo installation, naturally allows this sort of thing to happen. Where in memory we may edit out the museum experience when we think about Courbet, in public art that distinction is harder to make. The work is already part of the world. So too with an object made by the British artist Lubaina Himid (Fig. 25), which was placed on the beach in Folkestone on the south coast of England, where it still sits. Approaching it from the town, we enter the transitional zone of the beach itself, which is part-land, part-sea. Our physical behaviour shifts at that point, as it naturally would. Our movements slow, perhaps, as the wind off the sea resists us – or nudges us forward, depending on the weather. We're in a heightened state, with an increased sense of our own physicality, which might have been barely noticeable on the smooth pavements in the town. The smell of salt water, the cry of seagulls, the distant noises of other people, the crunch of shingle, the sparkling light on the English Channel – all of these are sensory events we pick up on before we're even aware of it. The object itself, part-sculpture, part-architecture, sits on the beach but is not like it: it's a human-made thing that makes no attempt to blend in to its surroundings. Once we arrive and enter into it, our experience of the object and of the beach itself is utterly changed. The close acoustics within it generate a kind of intimacy. Its structure provides some protection, at least overhead, and it's a protection that feels welcoming, especially in the English summer drizzle. So the object's placement rests on two different sensory experiences: the outside and the in. The sea's framing through the spindly, twisted

columns makes it into a vista, like a seascape, or a photograph you
might take on a day trip to the seaside.

Inside and out, the structure is decorated with complex repeating
patterns that rhyme with the site: some shapes are like pebbles and
shells, others like undulating waves. It's a style of decoration that
might call to mind other architecture in the town, but in any case
makes the structure part of an idea of the landscape as something to
be prettified. It's a traditional view of the seaside that might speak
more broadly to human relationships with the world we inhabit.
But as a viewer sits on one of the seats, taking in the pastel patterns
of the dome's interior, there's no sheltering from the elements. The
object tames the world outside, but its openness to the wind and
light makes it a part of it, too. It's both porous and protective, assert-
ive and frail. Its delicacy, on certain days, can make it seem festive
and celebratory, but when the wind and rain beat down, it's not a
place you'd rush to for shelter and warmth. Because Himid's work

FIG. 25 Lubaina Himid, *Jelly Mould Pavilion*, 2017. Fibreglass mouldings.
Folkestone Triennial

is permanent, these complicated relationships with the world outside shift continually. On a bleak February afternoon it looks like a beached jellyfish, yearning for the ocean.

The meanings of Himid's work hinge on the porousness of the art object, the way it's a part of the world and partly draws its powers from it. Most artworks we encounter are within interiors, which means they've already edited out much of the world beyond. It's not unusual for visitors to emerge from a museum or gallery, for instance, dazzled and dazed by the sudden plunge back into the everyday. The implication is that the art space is a different *kind* of space to that of the ordinary world. The reproductions of works of art that are our principal point of access to art experiences suggest that, too. Gradually, as the interest in certain artists increases, and more and more books and articles are written about them, these reproductions start to become substitutes for the real object. Unlike the original work of art, they are infinitely reproducible, portable and shareable, especially online. You'd have to be a very dedicated curmudgeon not to see this as a positive enhancement of public engagement with artworks, and an extension of the imaginative footprint of art. But it's not simply the scale and surface qualities of the original object that these reproductions lack, although those are highly significant. It's the unique way in which works of art are interwoven with human bodily life, with experiences of space and weather and other people, and from which their meanings gather additional potential. Images of an empty art gallery might represent a useful ploy for the sale of museum memberships, or the inducement to donate to an institution; but artworks are part of, not separate from, the world we share with them, and require human contact to come to life. Their porousness is how they maintain the ability to speak, and why they are worth looking at in the first place.

FIG. 26 Helen Levitt, *New York*, c.1940. Gelatin silver print, 19.1 × 12.7 cm. Museum of Fine Arts, Houston

Content

What's it all about?

L ET'S imagine we are encountering the strange and compelling image that is Fig. 26, a photographic print by the American artist Helen Levitt, on the wall of a museum. In the most likely scenario in which we might see it, it's framed and hung alongside other photographs made around the same time, possibly even on the same theme. The wall is painted a neutral tone, probably off-white or grey, somewhat like the range of tones in the photograph itself. The effect of this display might be taken in all sorts of ways, but its intention is probably to minimise visual distraction; it's designed not to be noticed as we look at the work. This is a fairly small print, about 20 by 13 centimetres, so it's really only viewable by one person at a time, and it's a complicated one, which reveals its parts only slowly. Honing in on it at the expense of everything around it, then, might be desirable. Like all great works of art, the imaginative return on the viewer's investment of attention is endlessly rich. But let's continue to imagine this encounter in the museum space. After a brief glance at the object, not long enough to register much of what it contains, we turn to the label. The information we receive there is of some use in our looking, however minimal it might appear. We're given the artist's name, the dates of her life (1913–2009), the title and date of the photograph, *New York*, *c.*1940, and its medium,

gelatin silver print. Even without additional explanatory material, we've already been given a good amount to go on, and we can turn back to the photograph with a slightly sharpened vision.

We've been referred to a specific place and time (New York, *c*.1940) but the title makes no reference to the human characters that throng the scene. That might in itself be interesting, and worth thinking about. It also might well not be the artist's choice of title – which is *also* interesting. This simple thought process is relevant for the title of any work of art, and thinking it through might be useful. Already we are in the throes of interpretation, since regardless of who came up with that title (the artist or someone else), and whatever reason they had for doing so, they did so after the event shown in the photograph was in the past. Giving a scene from real life a title is itself like taking a photograph: it's a means of distilling meaning from the mess and noise of everyday existence. The title may even have been dreamed up long after these children had passed into adulthood. See how the image changes in the light of that possibility. How a fleeting moment in their lives, probably something none of them had any memory of, became, through the process of being changed into an image and given a name, freighted with additional meanings they never intended, many years later, even after their deaths.

And how about that date? Its historical resonance aside – although this is America, not Europe, so the war is far away for now – how accurate is that 'circa', and does it matter? That kind of hedging of bets is very common on museum labels, and provides a glimpse into the world of scholarship that lies beneath the label. At what stage in the artist's life and career did she decide to take the photograph, which was almost certainly one of many she took as the scene unfolded on the New York pavement, and then develop the film and choose this particular shot to print and show? Which images did she discard, and why? Why is the image cropped like this on the right-hand side, making three of the children not fully visible? And why take the

picture anyway; couldn't she have just passed by? And what was it like, in any case, to be a woman on the streets of New York around 1940, taking photographs of strangers, especially children she, we imagine, didn't know; what sort of freedom did she have to move around and do that sort of thing? The photograph itself is full of human characters inhabiting that single space in a range of ways, some casual, others tense. So where and how did Levitt herself fit into this picture? Who is she most like: the kid squatting to pick up the shards of broken glass, the whistling woman strolling alone, or the little girl standing awkwardly by the laundry window?

These are questions that could, of course, carry on going forever. Great art has the capacity to do that. It's surely one of the hallmarks of its greatness: that ability to germinate new thoughts in new heads. (Having said that, bad art produces its own set of questions, too.) These thoughts are by nature unanswerable questions thrown up by an experience of really looking at the object, and the fact that they can't be answered is part of the way works of art actually work. None of those questions would be satisfactorily dealt with in a single answer. The fact that art is not *like* data, that it takes a different form to it, is what allows it to take hold in our imaginations. But the data of history is the breeding ground of imaginative leaps, rather than the means to keep our thinking grounded. The invisible art-historical labour that lies behind something as seemingly simple as the date of a work of art is itself an interpretation, built of research, analysis and close looking. The knowledge of this can turn a plain museum label into a creative act. Even that date is by no means a stable event. What was the year 1940 to Helen Levitt? To the children in the photograph? To the contemporary viewer, armed with the historical hindsight of that momentous year? It doesn't take much to find new ways of thinking within even the most straightforward pieces of information.

Museum labels like the one just described are in fact among the most widely read pieces of art-historical scholarship, even though

they're usually treated as straightforward providers of basic inform-ation. Faced with a work of art we've never seen before, we might give it a quick look, then consult the label for the basic facts and some useful information, before looking back at it, armed with a bit of helpful data. Once we've learned, say, that the man is Jupiter and the woman is Juno, or that the guy in the wig is the Duke of Marlborough, we can move on to the next one. For the vast major-ity of visitors, who don't come armed with an art history degree, these textual footholds provide an entry point to the work of art. But what this kind of activity misses out on is thinking about the texts on the labels themselves as carefully composed writing. The information they put forward is often simply taken as objective fact. It might even be taken as somehow representing the 'truth' of the painting, as though signed off by the artists themselves. But paying attention to these labels, and thinking of them critically, allows us the space to think in a more nuanced way about art objects. Doing so will remind us of the fact that a museum's interpretation of its own collection, as literally spelled out on those explanatory labels, is just that: an interpretation. The content of these interpretations is very diligently thought through, and often the result of com-mittees of in-house experts painstakingly tweaking their contents. Assertions made about works of art are worded with care, in the light of scholarship about the artist and the work. Most of the time, the style of this writing tends to be detached, impersonal, and a bit bland. The effect is that of an authoritative voice speaking in a manner that is slightly anachronistic, not really of our time, as though the painting itself is speaking. It's the way art historians on TV sometimes talk. And it is, of course, an effect. It's theatrical. It implies consensus, that what you're reading is unshakeable fact, which has been agreed on long before you set foot in the building.

The voice of the text reassures a viewer who may not know what it is they're looking at that *they* (the voice) know, and that they (the viewer) can move along now. But this authority is a fleeting one.

Museum archives often contain the labels that were used in earlier points in the life of the institution and were subsequently replaced. They don't tend to show them in public, for probably obvious reasons, though they should, as a reminder of how dramatically ideas about works of art shift over time. The further you go back, the more the information changes: the date of a painting, its subject, even the artist's name can have undergone huge transformations. What was once a Rembrandt may now be by a completely different artist. The description of the work of art, too, may have undergone all sorts of amendments and rewrites. Each label on a museum wall is the very tip of a vast iceberg of scholarship and speculation. This is because art history itself isn't a settled business. Research is always revealing new, previously unknown information, which then reshapes the way history is told. But interpretation shifts too, and not just because of new information being brought to light. As audiences change, so too do the assumed contents of artworks, and what they might be seen to say. A description of a painting's narrative in a label from the 1950s, for example, would be very different on a label made in 2021 for the same painting. It's not simply a matter of language changing, though that's part of it. It's a case of the meanings of works of art *themselves* being subject to continual transformation as the world they live in changes. In a sense, works of art don't ever stay as one thing. Even as they are looked at, they become something different. This is because, no matter how ancient the work of art might be, it's only ever experienced in the present tense.

Museum labels are a revealing index of the way in which works of art are subject to informed guesswork that becomes a temporary truth until the next one comes along. Another way of framing this is to imagine all such labels being headlined with '*Until further notice, this is what we think this work of art is*'. Such texts are usually bracketed as 'interpretation' within the broader mission of the institution, alongside education programmes and other

forms of public engagement. But if we were to nudge that term a little – to play with the word 'interpretation' like a tongue with a wobbly tooth – we might see it as a creative act in and of itself. Treating art history as creative rather than empirical doesn't mean we'd trust it less, or refuse to engage with it. Instead, it might help breathe life into an intellectual activity that can feel remote and disengaged from contemporary experience. Rather than seeking a solid foundation of facts as provided by a label (or a historian on TV), we might instead see creative interpretation, based on attentive looking and awareness of sensory engagement, as central to the act of looking at and thinking about works of art. In this way of thinking, museum labels might become works of creative nonfiction, almost short stories, with historians performing the way artists themselves have always done: as creative interpreters of the past and present of human culture, making guesses based on the available information at time of writing.

That's quite a leap from the humble label, quietly doing its job on the wall of the museum. But these texts are a useful metaphor for art history itself, its fluctuations and erasures, and its sometimes distanced relationship with the artwork it speaks about. This is really down to a basic truth about how history itself works. History always appears after the fact – often long after it – and so builds its ideas out of whatever material it can scrabble together from whatever's left behind. The same is true of other forms of interpretation of the past, including archaeology, geology, palaeontology, and many other -ologies. Perhaps this kinship with the natural sciences accounts for that curiously detached tone of voice you often find on the labels in museums, or in much writing about art. It could be some attempt at a kind of scientific objectivity – which of course is itself a pretty questionable phrase. But if we're to shake that loose, we might allow even the content of works of art – what the work of art seems to be 'about', or what its subject seems to be – to be subject to individual engagement, just as scale and colour are.

Treating history as a creative act is likely to prove a fairly unsettling experience. Turning away from a work of art with more questions than answers might frustrate some viewers, but it is the case that any deeply held piece of knowledge about a work of art can be teased at until its ambiguities become plain. We might assume that a portrait of a sitter is a true likeness, for instance, although what constitutes 'likeness' shifts dramatically according to where and when the portrait was made – and where and when it is shown and seen. We might confidently announce that a given work of art is 'considered a masterpiece' – but we ought to ask who's doing the considering, and was it *always* thought of as such? (The answer is nearly always no.) There is always wiggle room for creative interpretation, even when faced with a seemingly impenetrable wall of veneration around a work of art. A certain kind of inflated language creates a blockade that can seem to leave little room for the imaginative viewer seeking their own point of entry into the work. It can take some tenacity to find it, but without it works of art can only be famous objects, rather than springboards for imaginative possibility. The danger of language-inflation is that a viewer can become the passive recipient of information about works of art that has been decided long in advance of them actually seeing the object, rather than an active and present viewer capable of finding their own imaginative path. The fact is that there is no right or wrong way to engage with a work of art, but it's possible to not engage at all, and one way of doing that is to treat art-historical information as unshakeable fact. A work of art can become an illustration of art-historical work, even an illustration of the label's text, rather than having its own physical life and complex possibilities. This is not unusual – in fact, it's very commonplace – but it is unfortunate, since it leaves viewers as nothing more than passive subjects, worshippers at the altar of data rather than creatively active participants in the making of meaning.

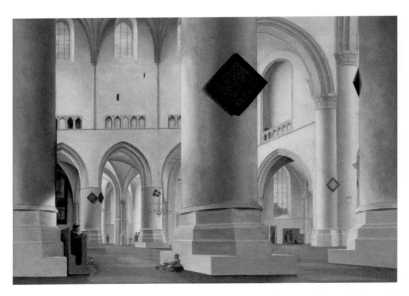

FIG. 27 Pieter Saenredam, *The Interior of the Grote Kerk at Haarlem*, 1636–7. Oil on oak, 59.5 × 81.7 cm. National Gallery, London

It's by no means only modern art, like Levitt's photograph, that holds the potential for this kind of open, imaginative questioning. How might we encounter a work like Fig. 27? Like the Levitt, it's likely to be hanging among other works of art made around the same time in around the same place, thereby making it part of a broader attempt to nail down the truth of a particular historical moment. This kind of display, which is the norm for paintings like this one, can be of use to the casual visitor seeking a little insight into a period they may know nothing about. Its label will do a share of this work too: the artist's name, the title, the date and the medium might (in part) be shared by other paintings in the room. What surrounds the painting, then, is a rigid structure of historical evidence that says *this is what the past looked like*. And there's something about the precision of a painting like this – how meticulously observed the interior of this building appears to be – that might

lead us to really believe that that's true. Paintings like this might be thought of as time machines, portals that lead directly into the past. But the problem with this way of thinking is that it reduces a painting like this to its surface content, to what it's 'of', which is a perennial issue in looking at older works of art, and one of the principal reasons museums with older art find engaging with modern audiences challenging. Why would a contemporary audience, they might ask, be interested in a picture of an ancient myth? Or a religious narrative? The fact that these sorts of questions are being asked clearly suggests an intention to broaden audiences to art museums and galleries. But perhaps they're the wrong questions in the first place.

If we treat the surface content of a work of art as all there is to it, then we're not really looking at it. By 'surface' or 'apparent' content, I'm referring to the subject matter that is usually the title given on the explanatory label: 'portrait of', or 'landscape near', or 'Venus and Adonis'. All of these suggest the surface-level subject matter of the work, which is often tied in with how and why it came to be commissioned, or what kind of location it was originally displayed in. Surface-level subject matter, in other words, is useful for art historians but generally less so for non-specialists. And in order to really enhance our experience of looking at works of art – especially ones we generally would rather pass by – it's essential to see these sorts of subjects as only one element, even quite a minor one, of why art has the ability to speak across time. It's a bit like talking about a film only in terms of its literal story. There's value in that, of course, but any deeper investigation of such things is going to need to consider all kinds of other aspects. Reading a review of a film will make it very clear that plot is only a fragment of how such things are critically valued, something that is most clearly reflected in the kinds of awards – music, screenwriting, costume design, cinematography, editing, not to mention acting and directing – that are given out. Let's take this painting, then, which has been placed

in front of our imaginations for a little while now, as an example of this idea of the limitations of surface content and how much more might be seen.

The label's information tells us the artist's name, Pieter Saenredam, the dates of his life, 1597–1665, the painting's title, *The Interior of the Grote Kerk at Haarlem*, the date, 1636–7, and the medium, oil paint on oak. Again, this is information that can immediately be dug into and revealed as more complicated than it might appear, regardless of how much we already know about the artist or the period he was working in. The artist, a European man in his late thirties, made, the label indicates, a painting of the interior of a specific building. What sort of knowledge might someone like him have brought to the experience of painting this? Was it a place – or the sort of place – he knew? How might he have inhabited that space: like those male figures that are dotted throughout the painting, confidently wandering and chatting, or was he a different sort of person? Did he work alone, or were there assistants – and what sort of place was it made in? How different was the experience of being in the studio to being in the church? How did the experience of literally being there (certain effects of light or sound, even the smell of the place) find expression in his work? (Did he run his hands along those columns to get a sense of their curvature and the feel of their surface?) And what sort of role might this bodily memory have played in the making of the painting? What kind of effect did the elapsing time between being in the building and depicting it in his studio have on the painting's appearance? To return to that title: its specificity (*this* particular church and not another) might suggest that this is a true rendition of the building's interior. But if it is, why? And if it isn't, why not?

An initial thumbnail description of the work's surface content – the view of the interior of a huge church, with whitewashed walls and barely any decoration, with a few people alone or in groups – cannot account for what makes it compelling, which it is to many

people. How true it is to the real interior of the actual church feels like nit-picking in the face of how the painting communicates certain ideas across time and space. Holding a postcard of the painting inside the real church and pointing out where he got it wrong seems like a pretty futile way to spend an afternoon, although it's a safe bet that someone's done that. The *effect* of clarity and accuracy, the sense of its rightness, is enough. Something ineffable in the artist's way of constructing his painting exudes a sense of certainty and confidence. This is conveyed by a precise touch of the brush, as well as a particular way of suggesting a pattern of deep and shallow space within the interior. The limited spread of different tones within the painting – pale blues into cream, grey, and peach – is itself communicative, as though the painting were speaking an entirely abstract language. The time spent moving one's zone of attention across alternately shadowed and illuminated spaces, which somehow allows us to imagine the experience of walking through a space like this, generates its own kind of meaning. The more concentrated this kind of looking – and this kind of painting, with its precision of observation, seems especially made for this form of engagement – the more the apparent subject of the work seems like an afterthought. Or, better yet, a kind of passport: the subject matter, in this case, provided the means for the painting to enter the world, but that is, of course, only the beginning.

Like poetry, a work of art can't be reduced to a description of the literal events or images it describes. Works of art that relate to a mythological or biblical story, as are common in western European museums, are often talked about in terms of that story and its principal characters, which is a drastic reduction of the works of art in question. Visual images are by their nature interpretations rather than equivalents for the narratives they derive from, and the written or spoken story is not *like* a painting or sculpture that's drawn from the same source. Like a poem, a painting's content is not separable from its effects; its content *is* its effects. But apparent

content does tend to overshadow the formal and physical qualities of art objects when works of art are talked about. You might easily overhear someone say, of a portrait, 'that's King Henry VIII'; but of course it isn't, it's a painting – though pointing that (important) distinction out might not be the best idea. Similarly, that sculpture of Apollo isn't Apollo; it's first and foremost a sculpture, and its maker is mostly thinking in terms of matter and the problem-solving associated with it, not of illustrating a mythological story. If popular art history has often become preoccupied with 'reading' works of art in terms of what they seem to be *of*, it's perhaps a product of the fact that most of them are only seen and discussed in reproduction, which makes it very difficult to engage with them in other ways. It's not that, when faced with a narrative you don't recognise, knowing the story isn't helpful – of course it is. It's simply that telling a story through subject matter, or telling a story *at all*, is only a small fraction of what any work of art does. Not engaging with its effects is like discussing a poem without mentioning rhyme or metre, or the sound of the words, or the fact that it is, first and foremost, a poem.

What this discussion really amounts to is a proposal to rethink what we mean when we discuss the 'content' of any given work of art. Rather than describing what it literally depicts, as a title on a museum label might, we could stand to benefit as viewers, and maybe even as artists, if we pull at the edges of the word and reconsider *how* the meanings of works of art might be communicated to us. The word 'content' might then be allowed to accommodate more than it usually does: not just the story but how the story is told. And we might also be able to find new levels of reward in objects we'd usually skim past because of what their subject matter seems to be. A sculpture of the Buddha, for instance, may have come into being to fulfil a religious function, and a specialist historian could certainly enlighten you on that context. But the object embodies other possible meanings that are available to anyone willing to

dedicate their time and to think in an expanded way. Works of art survive centuries of human history not because of the specific narratives they seem to tell, but because they have the flexibility to be able to continue speaking long after their particular context is gone. In fact, it's almost always something *aside from* the apparent subject of any given work of art that ensures its longevity.

Content as form

It might be posited that abstract art doesn't have any of these problems. After all, if it's not *of* anything, there's no subject matter to get in the way: you can engage with the fundamentals of the object in front of you. There's some truth in this, of a limited variety. But the idea of making art that doesn't start from visual experience – which is a loose and fairly accurate description of what abstraction means – doesn't actually imply that there's no subject matter. All art has a *subject*, even if it's not one that comes from the visible world. And if we look at art through a global lens, it's apparent that abstract art, in a loose sense, is the norm, not the exception, in visual art. It is neither a modern invention nor a Western one. This means that non-representational art has always been a means of communicating ideas; that content has, in fact, *always* been a matter of colour, line, tone, shape, placement and material. Put simply, most art is abstract art. So not having a subject drawn from the real world is no barrier to a work of art having meaningful content. It's a lesson that might be learned in front of Islamic calligraphy, Aboriginal Australian bark painting, or ancient Greek vases, covered in geometric designs. Or, in this case (Fig. 28), a sculpture from 2000 by the Indian artist Mrinalini Mukherjee.

One of the questions that might reasonably be raised by a first-time viewer of a work such as this one is: what *is* the content? The object in front of us has no apparent subject matter – it doesn't

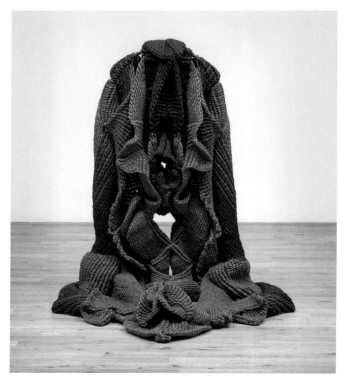

FIG. 28 Mrinalini Mukherjee, *Jauba*, 2000. Hemp fibre and steel, 143 × 133 × 110 cm. Tate, London

appear to be representational, although it might equally be described as not entirely abstract. It hovers somewhere between the two. Take a more expansive position on what content in art actually means, though, and such a distinction starts to look a little weak. If the content of a given work of art consists of a fusion of material, touch, colour and light, creating 'abstract' and 'figurative' camps in which to place the objects we encounter seems a frail basis on which to define things. Categories like these might help if we're tracing the shape of an artist's career, which might be character-ised by deliberate shifts in style, but in terms of the present-tense encounter with an actual object, they can close down rather than

open up the possibilities. In any case, finding specific content in *any* work of art is a sure way of sealing off potential imaginative routes. Remaining open to the complexity of works of art, even ones we think we already know, is the only means of ensuring that they generate new thoughts. It's a matter of what sorts of questions we ask. Let's not ask 'what building is this?' when looking at the Saenredam painting, or 'what street is that?' when looking at the Levitt – questions that can be answered with a quick piece of data that closes the conversation down. Rather than asking 'what is the content?' – or, in its more usual phrasing, 'what's that meant to be?' – let's instead take some time in refining our approach, and making our questions meet the experience.

One way of thinking about the way open questions can deepen our experience of looking at works of art is to think in terms of improvisation. In improvised comedy or theatre, a famous central principle is known as 'yes, and'. One performer invents a scenario, and their partner accepts what they've said and builds new information on top of it, a process that keeps on building until the players have collectively put together something out of nothing. While this is by no means a sure-fire recipe for hilarious comedy or compelling theatre, perhaps that isn't the point: it's a process by which the human imagination is loosened up, embracing the possibility of failure in pursuit of new ways of thinking. It's an approach that can enable us to both delve deeper into objects we might never have seen, and to refine the way we talk about them. In this case, our first observations of Mukherjee's work – the fact that it seems to be made of a woven fabric, or that it resembles clothing, or uses a palette of three muted colours – can form the starting point for deeper engagement with the object. Yes, it's woven – *and* the fabric seems quite thick and heavy, almost rope-like. Yes, *and* that brings with it associations of warmth and shelter. Yes, *and* the shape of the object is shelter-like too, like a dwelling. Yes, *and* it also recalls the leaves of a plant, that might protect a

bud. Yes, *and* the colour palette seems organic, like the colour of vegetation. And on and on.

This is a dialogue that can quite easily happen inside the head of a single individual, taking the object in for the first time. What's notable is that each observation grows out of the one before, so that the interpretation of the object is actually a single unfolding thought that is gradually refined and expanded upon with ever more specific reference to the object itself. This is an activity that can be done with a large group as well as two or three people. The collective approach is a useful way of reminding us that meaning often emerges through collaborative investigation, and that observation is a matter of perspective, not objective fact. Building on that interpretation might mean introducing salient facts about the artist's work, life and context, as provided by the museum itself. The process is, in fact, very like the academic processes that underpin art history itself, which build on and develop existing ideas about objects, rather than scrapping what's come before and starting from scratch. In no sense are these facts intended to contradict the flow of open interpretation described previously. If our ideas about works of art grow out of the objects themselves, and are nourished by continual contact with those objects, then they can't really be 'wrong', and no one can be reasonably accused of 'reading too much into them'. This is a common criticism that seems to imply that there is a certain limit to what it's possible to glean from something, as though there were a boundary around our imaginations. Reading too much into things is the only way to do it.

In this way, our idea of what the content of a given work of art might be is something we reach only quite late in the process. The answer is never going to be a literal account of what the work of art depicts. If we went through this same process with the Helen Levitt photograph discussed previously, burrowing into the complex layers of that image, opening our every observation up and growing new ones from them, we'd never be happy to conclude that it's 'a

picture of some kids playing with a broken mirror'. Instead, we would have dug into the possibilities of its content, finding there more profound ideas than a mere description of what its subject is could ever suggest. A similar thing happens when someone asks us why we love a film we love: just running through its major plot points will never convince anyone why it means what it does to you. Content, then, is baked into the object itself, and is only revealed through open acts of attention. In the case of the Mukherjee sculpture, the pattern of almost clenched weave and open space, of the tightly bound and the limply hanging, of the organic and the man-made, the shadowed and the light, is bound to release a world of imaginative possibilities for a viewer that persists in keeping the questions open, like a balloon continually bounced in the air so that it never touches the ground.

Let's look now at an object (Fig. 29) that relates to a specific story that has been told countless times in the history of art. In fact, people who approach this object with the knowledge of the narrative already in their heads might quickly read it in terms of how it tells that story. It may well be that the audience it was originally made to speak to may have done the same. Since it's a work of art that relates to a religious narrative, in this case a biblical one, there's a tendency to assume that its first audience would have seen it simply as an aid to prayer, or a way of understanding a story they probably would have been unable to read. These are assumptions often made by historians, which freeze the object in the moment of its early viewership, blocking off the exits to a freer interpretation, and turning out the lights. It's an obvious but important point to make that, in fact, we know nothing of how this object was perceived at the time. The fact that it even exists indicates that someone decided it was something that needed to be made, and perhaps the idea that visual art speaks more directly than the written or spoken word might have underpinned that decision. But we can't know, and we never will. We have to imagine that there

were many people, of differing ages, who *wouldn't* have known the story it tells, who might have approached it then as many of us do now: as a strangely distorted representation of human bodies and behaviours, something *like* the world we live in but also really not. That split, between the real and the unreal, is where the force of an object like this lies, and possibly always has.

The fact that this object is carved into stone in a flat panel means that our viewing of it is a little like that of a painting: we can't move

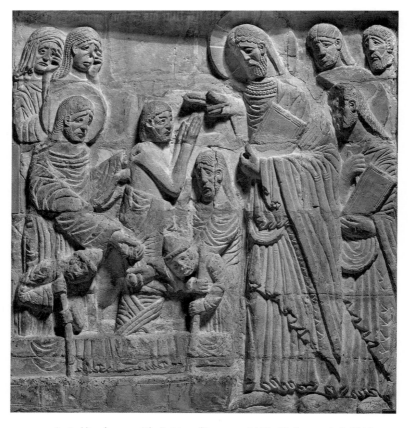

FIG. 29 Artist(s) unknown, *The Raising of Lazarus*, c.1125–50. Stone relief. Chichester Cathedral

all the way around it, and consequently the artists who made it are able to exert a degree of control over how the story is communicated. There are elements in the design, too, that indicate a desire to speak with clarity. The chisels that hacked into the stone surface dug deep into certain areas, defining particular parts, so that in the changing light of its setting, shadows would help to emphasise things. This already indicates to us that this sculpture was something made for a particular place by people who knew what that place was like, who knew its fall of light and the aesthetic of other objects it contained. It was conceived as an element in a larger pattern. Finer tools were used to evoke the patterns of fabric and hair without describing them scientifically. The effect is of a kind of shorthand, providing just enough for a viewer to go on. The more you look, the more you notice this kind of standardisation: facial expressions; the shapes of hands; even hairstyles. This allows many of the characters depicted to slip from *someone* to *anyone*. It lets the story open out. It means the literal story isn't as significant as how it's told. It could be your story, or mine.

The very largest figure in the carving fills the whole of the space from bottom to top, such that it's his body that creates the measure for the whole of the narrative. The relative smallness of other bodies in the sculpture creates a kind of hierarchy, where size suggests that character's significance to the story. The presence of haloes is another means of indicating importance, like spotlights on a stage. In this way, a cast of characters is set up, with the main parts clearly pointed out. Figures either side of the principal character tilt their heads in imitation of his, chorus-style. This makes the whole composition act like a set of parentheses, nesting around a simple central gesture: a hand pointing its first two fingers just above the head of a smaller, semi-clothed man, who's being held up by two other characters. Everything in the technical choices made while this was being carved seems hinged on that single gesture and its visibility. Two even smaller men hold tools, their heads bent down.

In the narrative, they are opening the grave in which the semi-clothed man was, until now, lying dead. He has been restored to life through that pointing gesture. But even without this information, the gravity of what's taking place is apparent, and it's told through the expression of faces, bodies, clothes and hands.

An explanatory label that accompanies this object in its home in Chichester Cathedral gives this object the title *The Raising of Lazarus*. That's the biblical narrative it interprets, in which Jesus Christ resurrects a devout man after he's been dead for four days. By its nature, it's a story that is impossible to understand rationally. It's a test of faith. The object was made in the twelfth century by unknown artists, who'd never seen a human come back from the dead – or at least only in their dreams. They may have been like those gravediggers, hunched over their chisels, just getting the job done. They may have believed, like the figures on the right, that the story was true, that they too might come back from the dead at the end of the world, as the Christian faith promises. But they may also not have believed a word of it. Like modern viewers, the literal subject matter may not have been knowledge they possessed. But their work is an interpretation of it. The technical decisions – how deep to carve, how much to show – create the deeper content of the object. The making of the work is where much of its meaning happens. Their labour is charged with possibility.

Translating an object like this into a textual description of its story serves to smooth out the elements in it that don't neatly fit that narrative. It would be a reduction. Not only are there characters shown here that aren't part of the biblical story of Lazarus, there's something important lost when we see narrative art as equivalent to something written or spoken. The decisions made in the making – the way the story is told, let's say – are at least as important as the story itself. So although this object does relate to the story of the Raising of Lazarus, its way of speaking – through the language of metal, stone and sunlight – is a different *kind* of storytelling. It's

as though the story is being sung. If we were to listen only to the words of the song, we'd be missing out on the melody and rhythm, which is where at least half of the meaning resides. The effect can be seen if we read song lyrics on a page, which can only ever feel thin and dry in comparison with the experience of the song itself. Because storytelling has been a common concern in art made across the world, the temptation to simply narrate the source narrative by way of engaging with the work of art can be hard to resist. Many explanatory labels in museums do just that. But unless we pay attention to *how* content comes to be expressed, we're really only seeing a small part of the picture. After all, there is no distinction between a story and its telling.

We started this chapter with a discussion of the museum label as a kind of fiction, built on scholarly research but subject to question and amendment. The label's (hidden) transformations are testament to how history itself is a flexible matter. The date given to a work of art is fluid in a similar way, in that conservation and restoration often lead to tweaks in the dating, but it's also fluid in a more profound and personal sense. No single date in history has a fixed meaning; it's an agreed-upon fact, of course, but the *experience* of that fact is where the interest lies. The 1937 that Pablo Picasso experienced (and made paintings in response to) was not the same 1937 that, say, an artist in Ghana did, let alone the millions of non-artists going about their business in other parts of the world. This is surely one of the most interesting aspects of the study of history: that two humans can exist simultaneously but live absolutely opposite lives. History (and the history of art) is weaker and more abstracted the less sensitively these dates are handled. In an artist's body of work, the dates of works of art always intersect with personal experience, however unaware an art historian might be of the details. Thinking of an artist's output as a chronological procession of objects rather than something interwoven with all the other events of human existence is to drain history of colour. A date on a work of art is

something easily overlooked, but, if really contemplated, provides an entry point to thinking about the actual experience of making the work in the context of a life lived.

All of this means that if we describe the painting in Fig. 30, made by the Japanese artist On Kawara, as 'just a date', we're overlooking the significance of what dates mean to human experience. A date can bring with it resonances of shared trauma (11 September 2001, for example) or of personal meaning (your birthday or that of a loved one) that give it a special force among other dates in the calendar. So this date, 21 January 1982, might have immediate significance to a viewer for any of those reasons. It may have none. Regardless, we know that to really pay attention to the seemingly objective fact of a date in the year is to allow it to reveal more than it might intend to, and this is a work of art that seems to invite that. It is *itself* an

FIG. 30 On Kawara, *JAN.21, 1982*, 1982. Acrylic on canvas, 25.4 × 33 cm. Dia Art Foundation, New York

act of attention, in fact. The date is painted with great care in white onto a field of blue, which Kawara has applied with an even stroke to create a smooth and level surface. Given its surface qualities, it's likely that the painting was made flat on a tabletop, rather than an upright easel. That in itself frames the artist's practice as being more like reading or writing than art-making, things associated with quiet and solitude rather than the physicality and noise of the studio. The experience of manoeuvring a brush around the curves of the number 8, for instance, is parallel to a kind of meditative focus. That sustained attention on the artist's part might itself generate unexpected new meanings from the simple data of the text. It's an act of such care and precision that questions might spring forth unbidden, such as: why *this* date? If it's the date the painting itself was made, like a magnification of the standard practice of adding a date to the corner of a painting, then it's a self-reflexive action: this is the date this date was painted. Such a gesture might serve to distil the process of making into a single poetic act. But if it's a different date, why is it this one? Regardless of which of these it is, the painting itself suspends the flow of time, which might be imagined cinematically, as the pages of a desk calendar tearing off and fluttering away, one after the other. Through the very act of painting, the artist has generated an intensity around that other-wise unexceptional data, which brings forth questions about the meaning of the time we all share. This means that the *content* of the work of art isn't the specific significance that the date has, or even the actual date itself – it's the attention Kawara gives to that date, and how that attention, made manifest in the way the object was made, might generate a sympathetic attentiveness in a viewer.

Kawara's painting, like an image of the interior of a church in Holland, a group of children playing on a New York pavement, a woven structure in three colours or a carving of a man raised from the dead, brings together subject matter and manufacture to give that statement force. Extracting subject matter from this weave and

isolating it as a single element fails to address the subtle ways in which what a work of art says and how it says it are inextricable. The characters Hamlet, Jane Eyre and Harry Potter do not exist separately from the language used to construct them; they can't be plucked out of the text and made to perform elsewhere without conjuring the original world that they inhabit. They *are* the text. The same goes for works of art. Any subject in a work of art – from an Aztec god of death to the Queen of England – is built out of the materials of art. The way we think about what works of art might be about always needs to be tempered by that understanding.

CONCLUSION

You're standing in a fairly crowded museum, looking at a work of art you've never seen before. It could be anything: a fragment of ancient pottery; a video projection composed of footage found on the internet; a still-life painting of rotting fruit; a porcelain sculpture of a flirtatious couple; a quilt stitched with an abstract pattern; a photograph of a baby's foot. Any one of these objects might form the centre of a lifetime's worth of research and analysis. Equally, any one of them might be glanced at for a couple of seconds, passed by and instantly forgotten. These two extreme possibilities reflect the simple choice anyone has when encountering a work of art. In any art experience, you have a decision to make: should you stay or should you go? The only decision that really matters is that one. Either give your time to the experience, or move along; there is no middle ground. Not that it's an easy decision to make. The fact that museums, even quite small ones, are so full of works of art, sometimes stacked up floor to ceiling, means that it's quite easy to expect the objects they contain to be as quickly taken in visually as the room itself is. Other art contexts make consuming art slowly a challenging, even impossible feat, from the overwhelming array of things to take in at an art fair to the sometimes charged environment of the commercial gallery space, which is primarily designed for buyers rather than viewers. Given such tricky conditions, it's no wonder that high-speed consumption is the norm rather than the exception in most of our experiences of art. Stately homes are experts in the art of suggesting that speedy looking is the way to do it: you can sweep through

room after room, passing hundreds of paintings and sculptures and items of furniture, and feel you'd seen it all. But every work of art is like a well: each one contains mysterious and echoey depths that are waiting for someone to decide to stay and peer into them. And once that decision is made, and stuck to, they stop being just things on the wall or objects on a pedestal and come to life. It's a decision that anyone can make.

Looking at art is a skill, and like any skill, it can only be enhanced through practice. That's not to ditch the gut reaction as an important factor in how we come to engage with art: it can often be a useful guiding principle. But the gut wants to move on, possibly to the next meal, and art needs time. Improving skills of looking can of course be honed through reading and research; art-historical knowledge, which is increasingly available to anyone, will always help to carry art experiences into new areas of understanding. But nothing beats time spent just looking. Fighting the urge to move on to the next thing is the principal way of developing that skill, but it's also about being willing to draw on many aspects of your own experiences in the world, as this book has explored. When we read fiction, we tend to do this without even being aware of it: the settings of stories become ones we ourselves already know. Our imaginations quickly fill in the gaps. Our experiences of engaging with visual art would be enhanced if we were willing to do the same thing. As alienating as museum interiors can feel, they are, in fact, part of the world – just as are the interiors of commercial galleries, religious buildings, artists' studios, private homes, royal palaces, and all the other places we experience works of art in real life. One way in which we might hone our skills of looking, and find enjoyment in doing so, is in remembering that works of art are embedded in the world we know. After all, art is something made by and for human beings. It's a deeply obvious point to make, but some of the language around art, which treats artists as other-worldly beings possessed of superhuman abilities, can create a distance between

the act of making and the experience of seeing. Art's world is in fact the same one we all occupy.

Like books, artworks seem to change in parallel with their audiences. Returning to a work of art you think you know after a period of time away from it is always an instructive experience. Things almost always seem to have changed. What once seemed drab and dull is suddenly intimate and warm; what once looked throwaway, not worth your time, becomes compelling. It can happen the other way round, too, of course: art you once loved can lose its sparkle over time, although it's you that's changed, not the art. These changes of mind are what keep works of art alive, and they're a result of how art lives within human experience and is nourished by it. It's because the meanings of any given artwork are always partly generated by the viewers themselves that they can maintain their perpetual freshness. Every work of art we see recalibrates what we saw before, and can provide new frames of thinking about whatever comes next: not just the next artwork, but the next experience in our lives.

The decision to give our sustained attention to a single object, especially one which generally stays still and silent, is a very unusual, even anachronistic event in the modern world. That act of attention is unlike most other experiences we have in a normal day, in which we quickly read and interpret sequences of physical spaces and interactions, before moving on to the next one. Living as we do in a highly mediated culture, with personal and professional relationships and many cultural experiences filtered through digital interfaces, this simple real-time, real-world activity might seem alien, or even eccentric. But giving our time over to the experience of looking at and engaging with objects made by other humans – in real space – is of untold value in terms of social and emotional intelligence, as well as sheer enjoyment, and it's something we all have the ability to do. The skill of looking starts from scratch, whoever you are. The fact is that the act of attention, of dedicating time to *this* object, in *this*

place, is very like the act of making art itself. Looking at art is much more than a skill, in fact: it's an art. The art object – that fragment, that video, that photograph, whatever it might be – represents the point of contact between two different human experiences that might be separated by vast distances of time and space, or even by life and death. The creative act is anyone's to make. You just have to make the choice to stay.

FURTHER READING

David Batchelor, *Chromophobia* (Reaktion Books, 2000)

Laura Cumming, *The Vanishing Man: In Pursuit of Velázquez* (Vintage, 2017)

James Elkins, *Pictures and Tears: A History of People who Have Cried in front of Paintings* (Routledge, 2004)

Amy E. Herman, *Visual Intelligence: Sharpen your Perception, Change your Life* (Houghton Mifflin Harcourt, 2017)

Dave Hickey, *The Invisible Dragon: Essays on Beauty* (University of Chicago Press, 2012)

Robert Hughes, *Nothing if not Critical: Selected Essays on Art and Artists* (Vintage, 2001)

Michael Jacobs, *Everything Is Happening: Journey into a Painting* (Granta, 2015)

Michael Kimmelman, *The Accidental Masterpiece: On the Art of Life and Vice Versa* (Penguin, 2006)

Olivia Laing, *Funny Weather: Art in an Emergency* (Picador, 2020)

Tom Lubbock, *Great Works*: *50 Paintings Explored* (Frances Lincoln, 2011)

Janet Malcolm, *Forty-One False Starts: Essays on Artists and Writers* (Granta, 2014)

Jerry Saltz, *How to Be an Artist* (Ilex Press, 2020)

Peter Schjeldahl, *Hot Cold Heavy Light: 100 Art Writings 1988–2018* (Abrams, 2020)

Ben Street, *200 Words to Help You Talk about Art* (Laurence King, 2020)

Sarah Thornton, *Seven Days in the Art World* (Granta, 2009)

Ossian Ward, *Ways of Looking: How to Experience Contemporary Art* (Laurence King, 2014)

Lawrence Weschler, *Vermeer in Bosnia: Selected Writings* (Random House, 2006)

ACKNOWLEDGEMENTS

Thank you to Sophie Neve at Yale University Press, whose initial and ongoing enthusiasm for this project has sustained it throughout the writing process. Many thanks also to Julie Hrischeva, for her expert guidance; Henry Howard, for his outstanding editing; and all of my family, near and far, especially Mar and Valentina, for their constant support and love.

PICTURE CREDITS